HADDINGTON

THROUGH TIME

Jack Gillon

AMBERLEY PUBLISHING

Haddington is one of the best tonics I can prescribe in a world that seems none too sure of itself. Nothing could look more permanent than Haddington. Its wide long main street is built for eternity.

H. V. Morton, *In Scotland Again*

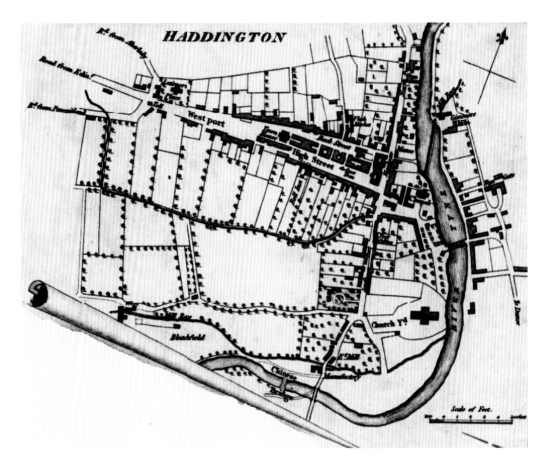

Haddington in 1822

First published 2015

Amberley Publishing
The Hill, Stroud, Gloucestershire, GL5 4EP
www.amberley-books.com

Copyright © Jack Gillon, 2015

The right of Jack Gillon to be identified as the
Author of this work has been asserted in accordance with
the Copyrights, Designs and Patents Act 1988.

ISBN 978 1 4456 4384 7 (print)
ISBN 978 1 4456 4411 0 (ebook)

British Library Cataloguing in Publication Data.
A catalogue record for this book is available from the
British Library.

Typesetting by Amberley Publishing.
Printed in Great Britain.

Introduction

Haddington was made the first chartered Royal Burgh in Scotland by King David I in 1128. Burgh status assigned trading rights and encouraged Haddington's growth into an important market town. However, it was a place of importance long before that time. One tradition states that it was named after a Saxon lord called Halden or Huddin, who settled with his followers on the banks of the Tyne. The name may also derive from the town's association with Countess Ada de Warenne of Northumberland – hence Adington – who was gifted the burgh in 1139 on her marriage to Prince Henry, the son of King David I. Ada was the mother of Malcolm IV and, in 1178, founded a convent for Cistercian nuns dedicated to the Virgin Mary near the town.

Haddington was the fourth largest town in Scotland in the High Middle Ages (1001–1300) and its location on the route northwards to Edinburgh placed it in the way of many invading English armies. Such was the fear of incursions that a town wall was built in the early 1600s. The town's turbulent history is reflected in the fact that the earliest surviving burgh charter, granted by James VI, dates from 1624. It confirmed previous charters that had been lost in the many floods, fires and sieges that had affected Haddington.

In 1216, Haddington was pillaged by King John of England during his raid into the Lothians. Thirty years later, the town was again badly damaged by fire. In 1355, Haddington was again sacked and razed to the ground by Edward III's army. The 'gentle Tyne' has also been less than placid on numerous occasions and it has been the cause of serious flooding of the town. Major floods were recorded in 1358, 1421, 1775 – when the river rose 17 feet above its normal level – and also 1846. There was a more recent serious flood in August 1948.

The most significant event in Haddington's history was the siege of 1548, when the English seized and fortified the town against Scottish and French armies. The English long resisted; however, an outbreak of plague appeared among the garrison, and they were forced to evacuate the town.

Haddington was at the centre of the agricultural revolution in the mid-eighteenth century and the town's prosperity has always been related to the productivity of the East Lothian farmland. The early nineteenth century was a particularly prosperous period, due to the increased value and subsequent profits from grain at the time, and most of Haddington's fine buildings date from this period.

In more recent years, many older buildings have been sacrificed to accommodate the increased use of the car. However, there have also been initiatives taken to preserve the best of what remains of the town's heritage. The Lamp of Lothian Collegiate Trust, established in 1967, has been responsible for many outstanding conservation projects. These have included Poldrate Mill, Haddington House and the major restoration of St Mary's parish church.

Haddington is now the main administrative, cultural and geographical centre for East Lothian, with a rich history and outstanding architectural heritage. It has an enduring quality and most Haddingtonians would recognise the present-day town from the following description in the 1910 *Borough Pocket Guide*:

> The county town of Haddingtonshire is a royal and municipal burgh, pleasantly situated on the banks of the River Tyne, in the centre of a fertile and beautiful district. It gives a stranger the impression of being a fairly well-to-do place.

Acknowledgements

Many thanks to the Revd John Vischer, of Haddington West church, for providing access to the church tower, and also to Bill Scott for help with the Buttercup Dairy images. Thanks also to Eilean Malden at the John Gray Centre, who helped track down the location of the statue of John Home – Haddington is very fortunate to have the John Gray Centre as a heritage resource.

The Lost Haddington Facebook page is another fantastic resource for all things related to Haddington. Lost Haddington is inspired by Lost Edinburgh, which is run by my good friends, David McLean and Fraser Parkinson.

The coffee at Diggory's was always very welcome and deserves a mention. Many Haddingtonians stopped to offer advice as I wandered around the town, which left the impression that Haddington is a very friendly and welcoming place.

As ever, a huge thanks to Emma Jane for her support and encouragement.

Jack Gillon

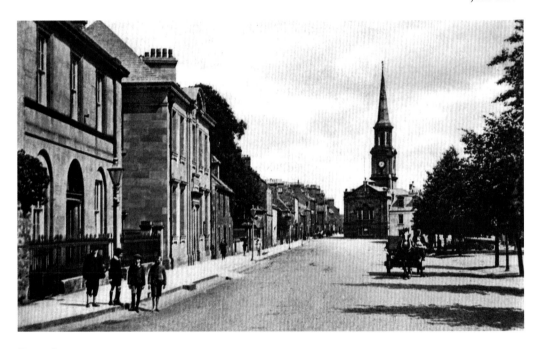

Court Street

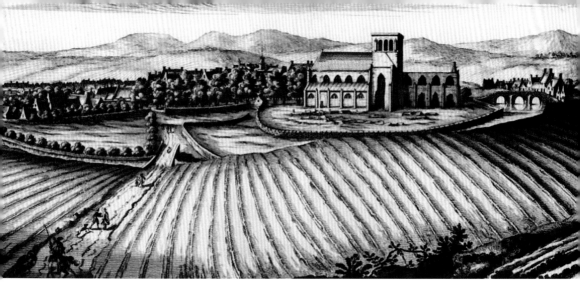

Haddington Panoramas

In his book, *In Scotland Again*, H. V. Morton wrote, 'All around Haddington lie the fat farmlands of East Lothian. There is no finer land in the country and no finer farmers. Haddington spreads over this rich region an air of prestige and experience.' The land around Haddington is some of the best farming country in Scotland. Agriculture has thrived in East Lothian for centuries, due to its fruitful soils, temperate weather and the use of pioneering farming techniques. The farming industry has been fundamental to Haddington's prosperity and growth. The panorama of Haddington from the south is dated 1693 (*above*). It shows St Mary's parish church, which was 300 years old when the print was made; the sixteenth-century Nungate Bridge, one of the oldest in Scotland, and the old houses of Giffordgate. Farmland extends to the boundary of the church. The late nineteenth-century image of Haddington (*below*) was taken from Harperdean, to the north of the town. It shows Haddington in a more rural setting with a neatly stacked harvest of grain in the fields. The road running centrally through the image is the present Florabank Road, Victoria Park and Newton Port. The twin gables of the 1838 St John's church are prominent to the right of Newton Port. The fields in the foreground have long since been developed for housing.

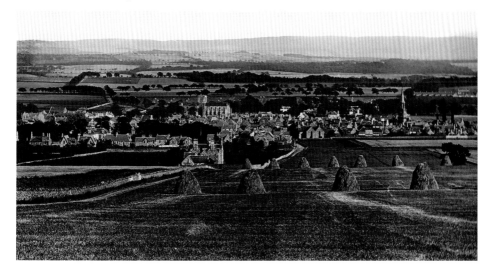

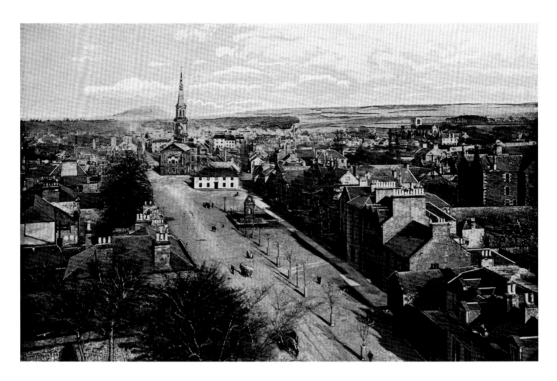

View from the Tower of Haddington West Church

These images, separated by over 100 years, show views looking east over Court Street and Haddington from the top of the tower of the present Haddington West church. The older image is from the late nineteenth century, with recently planted trees on Court Street. The overall view has hardly changed, apart from the vehicles and road markings in the new image, and is a testament to Haddington's enduring qualities.

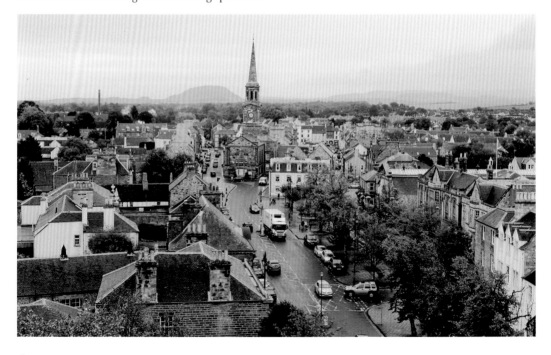

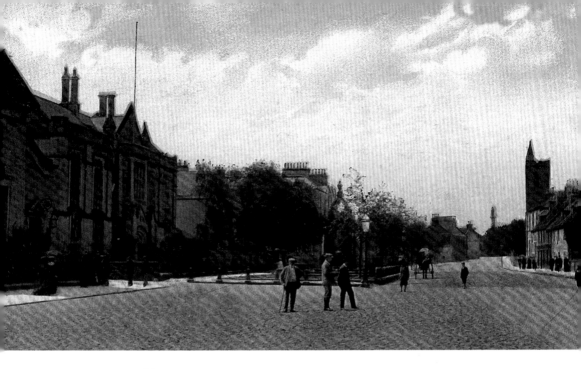

Court Street, Looking West

Court Street, with its fine early town houses, forms an elegant approach to Haddington town centre from the west. The older image shows Court Street as an elegant piazza interrupted only by the Tweeddale Memorial. Court Street is shown as West Port in early maps of Haddington and at one time was also named King Street. Haddington Palace, where King Alexander II was born in 1198, occupied the site of the present county buildings.

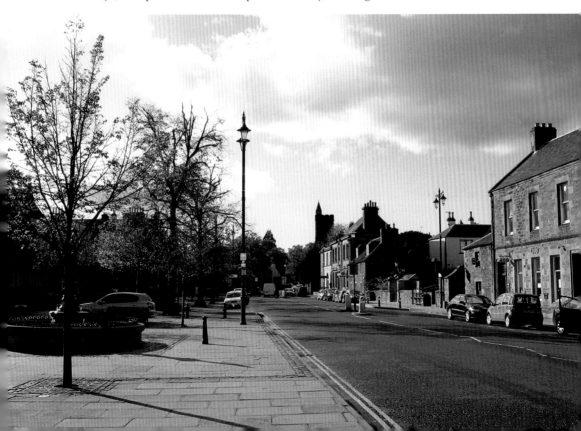

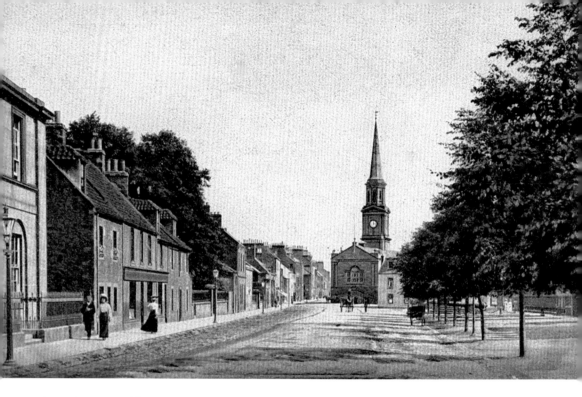

Court Street, Looking East

The two images, separated by 100 years, show a remarkably unchanged view of Court Street with the town house as the focal point. The corn exchange building on Court Street dates from 1854 and was once the centre of Haddington's thriving grain market.

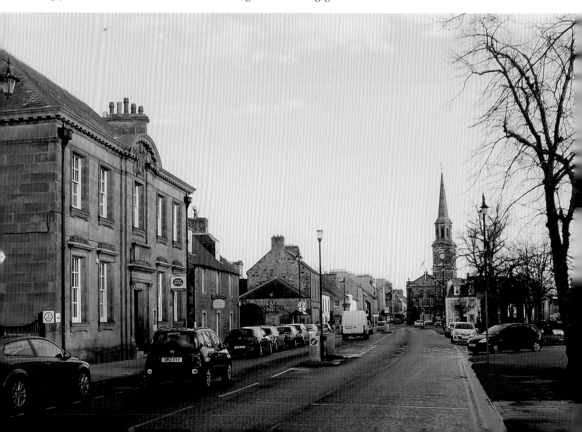

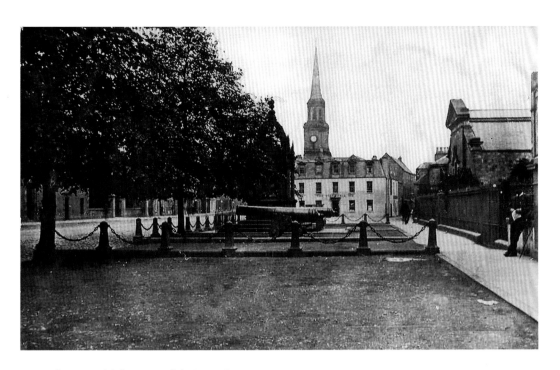

The Tweeddale Memorial, Court Street

The Tweeddale Memorial was unveiled by the Earl of Wemyss and March on 17 October 1884 in memory of George, 8th Marquess of Tweeddale (1787–1876), the Fighting Marquess. The monument was modelled on an old Scottish fountain in front of Pinkie House and includes a marble bust of the marquess. The marquess was lord lieutenant of Haddingtonshire and a distinguished soldier and statesman. The Crimean cannon, stone bollards and chains in the older image have long since been removed. The Tweeddale family estate was at Yester House.

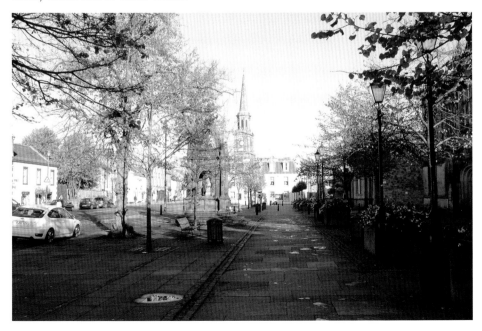

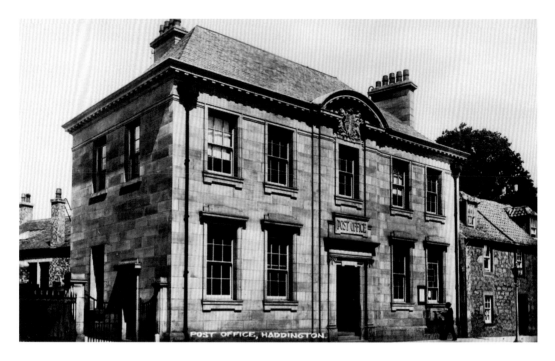

Post Office, No. 50 Court Street

Apart from the street lamp, some additional signage and parked cars, very little has changed in these views of Haddington post office. The postal service in Haddington has a long history. Haddington's first post office on the Sidegate opened in 1603, making it one of the very first in Scotland. The current elegant, two-storey building opened in 1909.

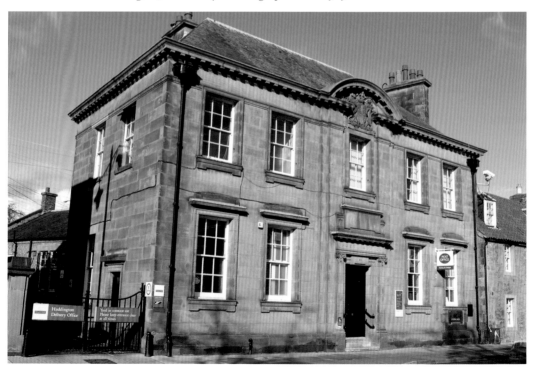

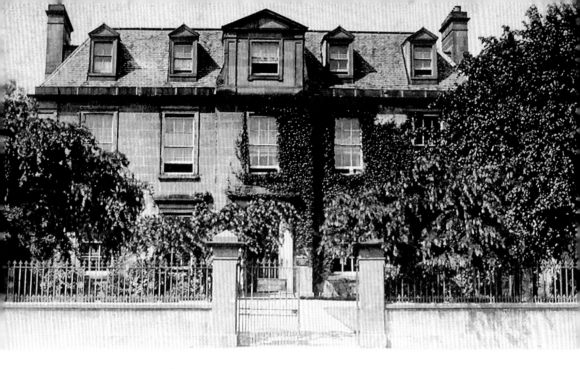

Royal Bank of Scotland, No. 32 Court Street
The Royal Bank of Scotland occupies one of the most elegant early nineteenth-century classical buildings on Court Street. The building, which was then a house owned by William Dodds, was the last resting place of Jane Baillie Welsh Carlyle before her interment at St Mary's church on 26 April 1866.

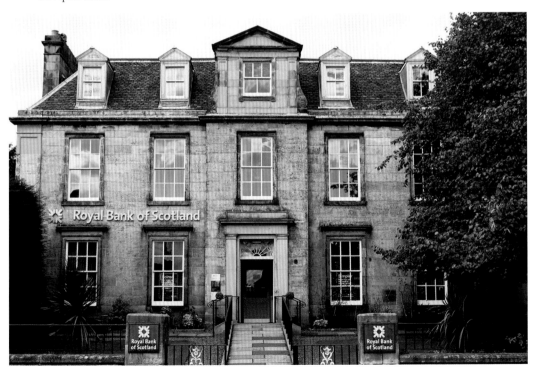

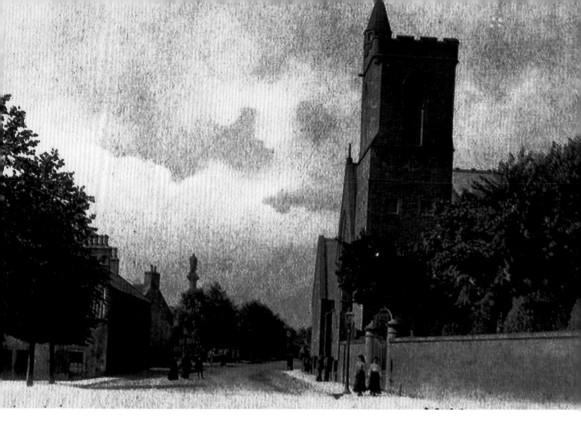

St John's United Free Church, Court Street
The church and its distinctive square tower is a landmark at the west end of Haddington. The building dates from 1890, when it was St John's United Free church. It became the West Church of Scotland in 1932.

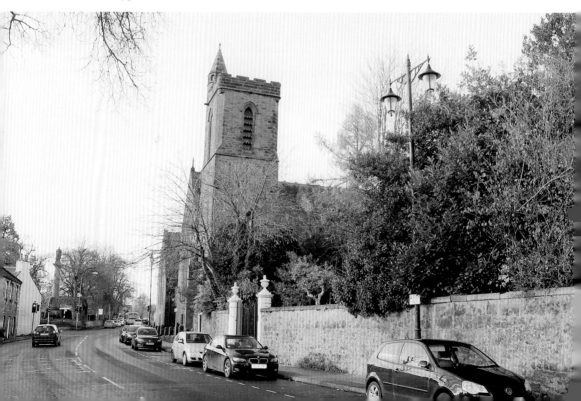

Ferguson Monument

The monument to Robert Ferguson of Raith was sculpted by Robert Forrest out of a single block of blue whinstone from a quarry at North Queensferry. A contemporary *Scotsman* article noted that 'it was the first attempt to use native whinstone in sculpture and that it had been eminently successful'. The monument cost £650, which was raised by the tenantry of East Lothian and Ferguson's other friends and admirers. It consists of a 45-foot-high fluted Doric column topped with a statue of Ferguson and four life-sized figures representing justice, science, art and agriculture at the base of the column. It was first 'exposed to public inspection' on Friday 2 June 1843. Following the unveiling, 'fifty gentlemen dined together in the George Inn to celebrate the event'.

FERGUSON MONUMENT HADDINGTON

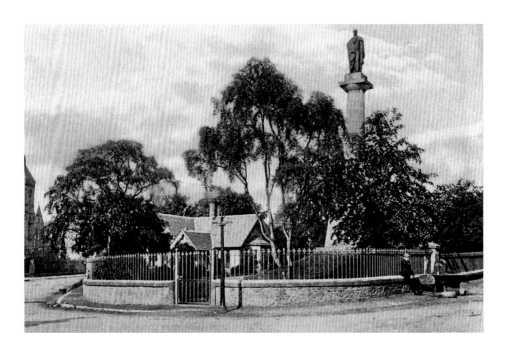

Ferguson Monument and Monument Cottage

The inscription on the monument, written in 1843, reads: 'In memory of Robert Ferguson of Raith, MP, Lord Lieutenant Fife, F.R.S.L., F.R.S.E., etc. A kind landlord, a liberal dispenser of wealth, a generous patron o! Literature, science, and art, an enlightened supporter of the interests of his country – this monument is erected by the tenantry of East Lothian, and many friends, of all classes, who united in admiring his public virtues, and to whom he was endeared by every quality which flows from goodness of heart.' Robert Ferguson (1767–1840) was born in Raith, Fife. He was a Whig MP and landowner with extensive estates and political power in Haddingtonshire (the name of the county was changed to East Lothian in 1921). He was also a respected amateur geologist and the mineral Fergusonite is named after him.

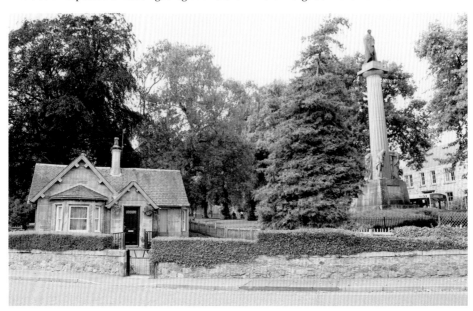

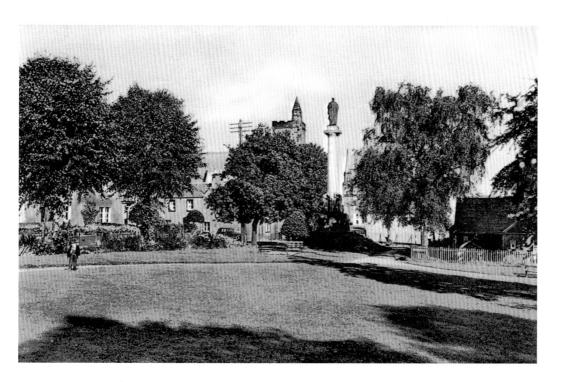

West End Park

Views towards the Ferguson Monument and Monument Cottage in the West End Park. The ground was part of the riding school and was used for drilling cavalry recruits and as a venue for cockfighting. The area was landscaped to form a setting for the Ferguson Monument. This was also the vicinity of the Gallows Green, where criminals were hanged and those accused of witchcraft were burnt.

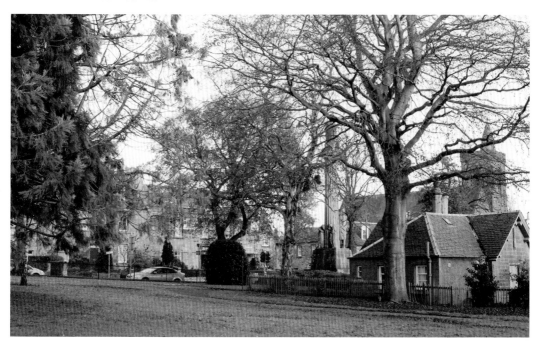

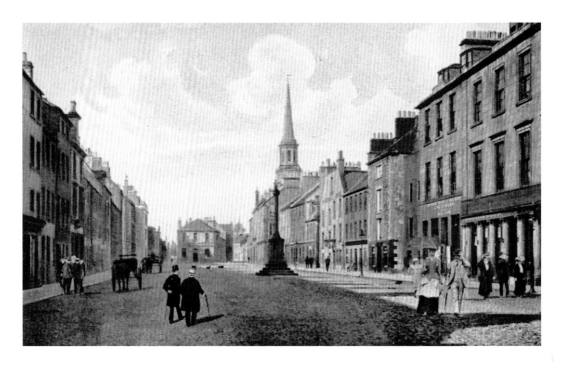

High Street, 1900s

These two contrasting images from the 1900s are looking west on the high street before the advent of the car. One shows what would appear to be market day, with loaded carts around the mercat (market) cross and groups of people in everyday dress obviously intrigued by the photographer. The other is a more gentrified scene with elegantly dressed Haddingtonians out for a leisurely promenade.

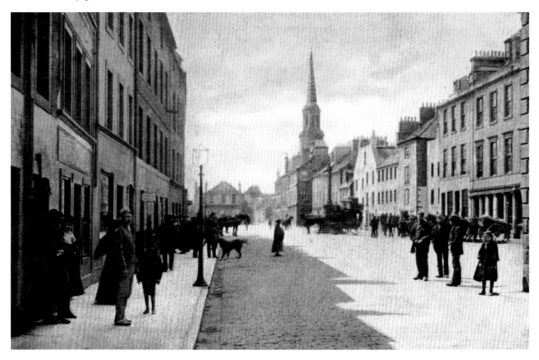

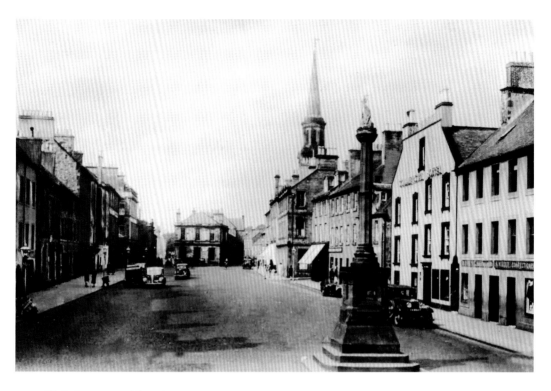

High Street, Looking West
The high street has always been the bustling centre of Haddington. There has been little alteration to the townscape in the space of time between these two images. The main change is reflected in the growth of the usage of cars.

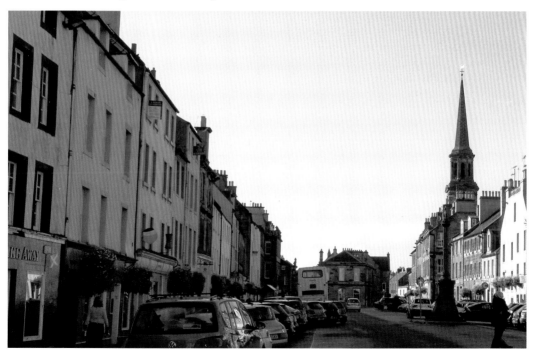

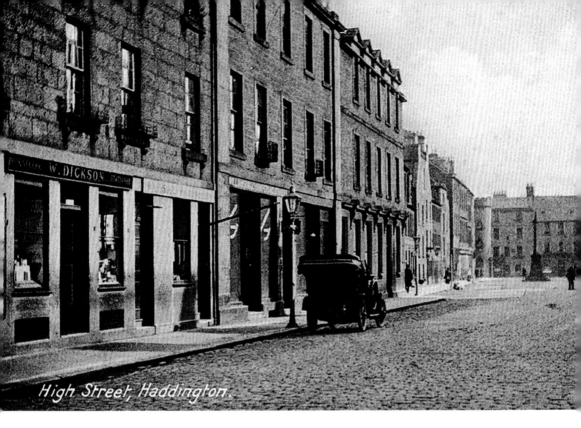

High Street, Haddington.

High Street, Looking East
These two images of the high street again reflect the remarkable changes in transport over the century. The wide range of independently owned shops, cafés and other outlets is typical of the vibrant town centre.

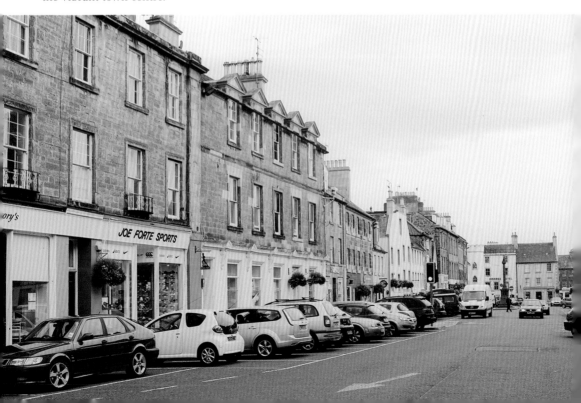

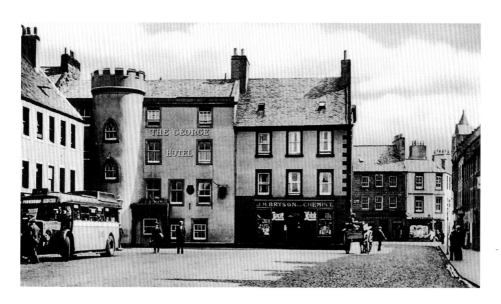

George Hotel, No. 91 High Street

The George Hotel, with its corner tower, is a prominent landmark at the east end of the high street. In 1910, James Stuart, the proprietor at the time, advertised the George Hotel as the 'Principal Hotel in Town'. It was well appointed, with a motor garage, billiard rooms, stabling and a large banquet hall. It 'purveyed for dinner, supper, marriage, picnic and dance parties'. Charges were 'strictly moderate' and to make a booking you phoned Haddington 17. The building stands at the core of the old burgh and has fabric that dates back to the sixteenth century. It was the principal inn of the town and the original old post house. It was at one point called The George and Dragon and was known as the Castle Hotel for a time in the twentieth century. In 1764, the hotel was owned by a James Fairbain and was one of the finest buildings in town. During its time as a coaching inn, its stables could accommodate twenty-three horses and four carriages. Daniel Defoe in his *Tour Through the Whole Island of Great Britain* described it as 'a good inn, not inferior to many in England'.

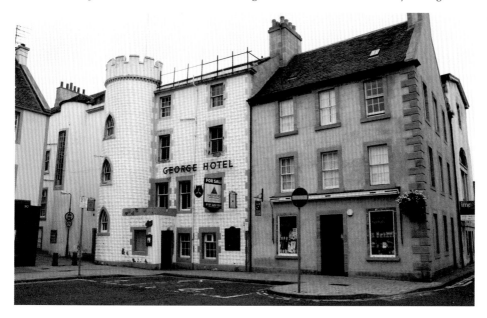

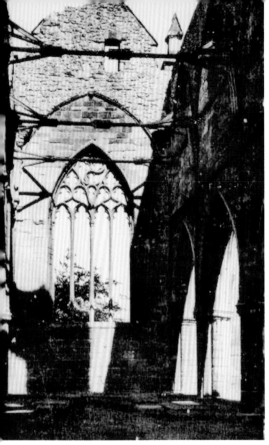

Jane Baillie Welsh Carlyle

Jane Baillie Welsh, the daughter of a local medical practitioner named Dr John Welsh, was born in Haddington in 1801. Jane, or Jeannie as she was known in her youth, became known as the 'Flower of Haddington' due to her great beauty and intellect. She was introduced to the then unknown Thomas Carlyle in 1821 by Edward Irving, her tutor and founder of the Catholic Apostolic Church, who later achieved fame as a preacher in London and subsequent notoriety when he was accused of heresy. Jane and Thomas then corresponded by letter until their marriage in 1826. Carlyle went on to become one of the most illustrious figures of his time – a historian, philosopher and writer.

Their relationship was stormy and it was said that, 'It was very good of God to let Carlyle and Mrs Carlyle marry one another, and so make only two people miserable and not four'. Jane was an excellent letter writer and, despite being encouraged by Charles Dickens to write novels, her literary output was restricted to the later publication of her letters. On 21 April 1866 Jane was taking a carriage drive around London's Hyde Park with a pet dog. She put the dog out to run and it was struck by another carriage. She gathered the dog and returned to her carriage. After a few more laps of the park, the driver, having received no instructions from Jane, found that she had died in her seat. Thomas arranged for her body to be taken to Haddington for burial and she was laid to rest in St Mary's church on 26 April 1866 beside her father. Carlyle's epitaph to Jane is engraved on the tombstone: 'She was born at Haddington 14th July, 1801, only daughter of John Welsh, and of Grace Welsh, Capelgill, Dumfriesshire, his wife. In her bright existence she had more sorrows than are common; but also a soft invincibility, a clearness of discernment, and a noble loyalty of heart which are rare. For forty years she was the true and ever-loving helpmate of her husband, and, by act and word, unweariedly forwarded him as none else could, in all of worthy that he did or attempted. She died at London 21st April, 1866, suddenly snatched away from him, and the light of his life as if gone out.'

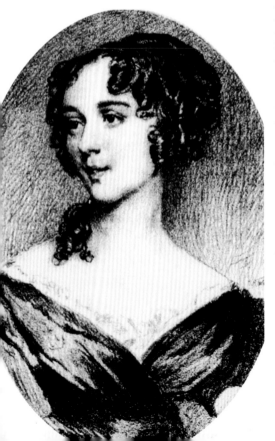

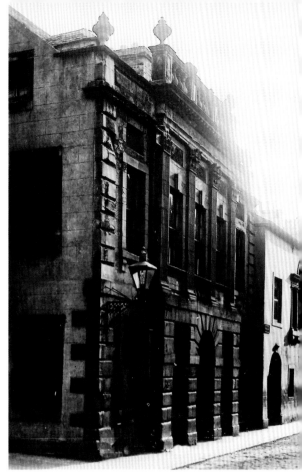

Carlyle House, Lodge Street
The classical frontage of the Jane Welsh
Carlyle House on Lodge Street. The
building was restored in 1981 by the Lamp
of Lothian Collegiate Trust.

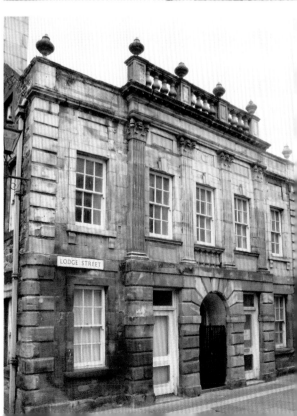

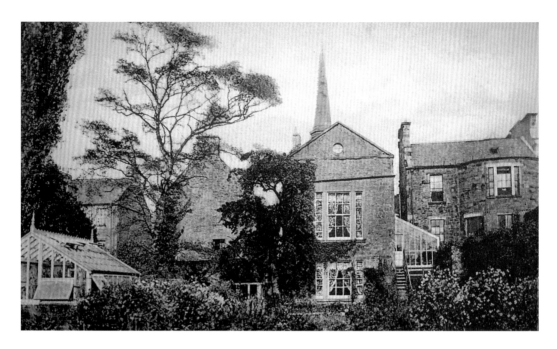

Carlyle House, Garden Side

The rear of the house with its charming restored garden is where Jane Welsh Carlyle was born. After her move to London Jane was often homesick for Haddington, although she rather unflatteringly noted in one of her letters that she considered the town to be 'the deadest spot in the whole universe'.

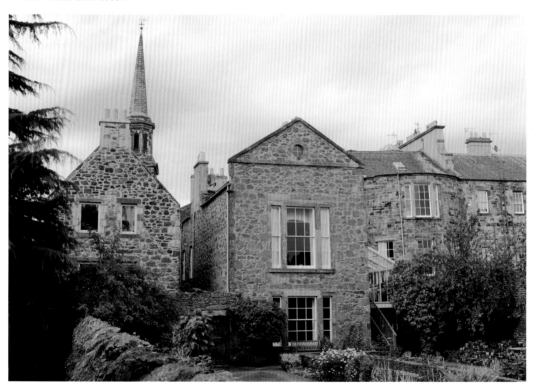

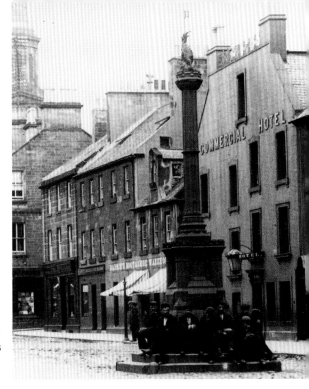

Mercat Cross, High Street

Mercat crosses were a symbol of a town's right to hold a market and an important privilege. Haddington's mercat cross has taken a number of forms over the centuries. The earliest in Haddington was probably a wooden structure erected in the twelfth century. The current cross was erected in 1881. It replaced an earlier cross dating from 1693, which met its end in 1811 when it collapsed during one daring individual's attempt to climb it.

In the time between the two stone crosses a wooden replacement was burnt down. The Haddington mercat cross is topped by a goat rather than a unicorn, which is the heraldic animal of Scotland. The cross was the site where criminals were punished by being publicly displayed in the jougs (a collar that was placed round offenders' necks and fastened by a padlock). There was also an old custom of drinking to the monarch's health at the cross. This was stopped around 1832, but in February 1840 large numbers drank to Queen Victoria's marriage and health at the cross.

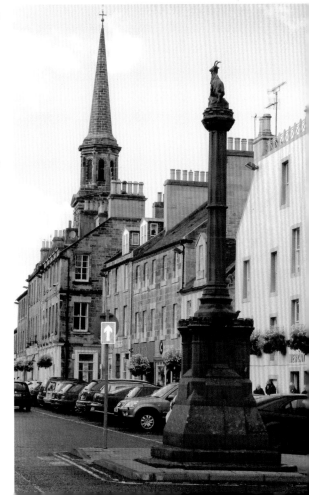

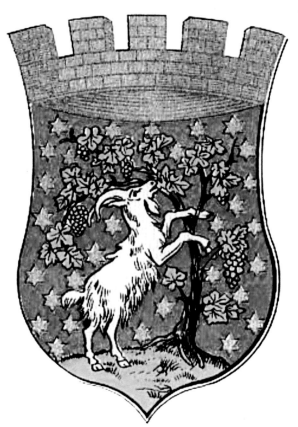

Haddington Goat

Haddington's coat of arms consists of two shields – one showing an enthroned King David I, who established the town as a Royal Burgh, and the other depicting a goat rearing on its back legs to eat fruit from a tree. The coat of arms was granted to the burgh in 1296 and the reason why a goat is immortalised in such a way has been lost in the mists of time. It is speculated that the fact that the goat is shown eating fruit from a tree reflects prosperity – the fruit being a tastier meal then grass. Whatever the truth, the goat is a ubiquitous feature in Haddington. The *Goats of Haddington* sculpture, depicting two fighting goats, was gifted to the town in 1978.

Goats are good climbers; here you see
This, active goat has climbed a tree,
And on the top will sit and eat
That bunch of leaves so green and sweet.

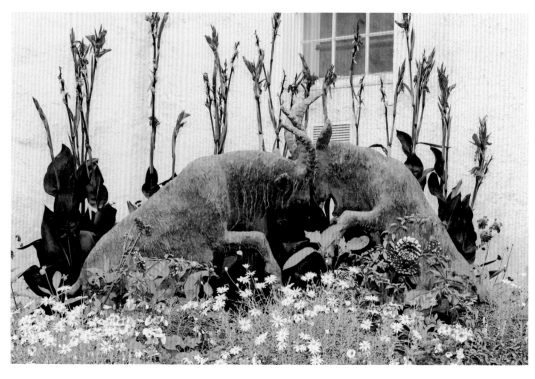

Haddington Town House

The steeple of the town house is the most conspicuous feature in the approach to the town from the west. The original building was designed by William Adam and completed in 1748. It housed the council chambers, the court and the jail. The original building was enlarged in 1830 by the addition of the town hall, and a 150-foot-high ornamental spire designed by James Gillespie Graham. The building was comprehensively refurbished for the Coronation in 1953 and was visited by the new Queen shortly after. The corn market was held under the arches of the town house until the corn exchange was built in 1854. The older image shows a small garden enclosed by railings and a bust of John Home, the author of Douglas, at the front of the building. The statue was moved to outside the former library at Newton Port and is now in the church at Athelstaneford.

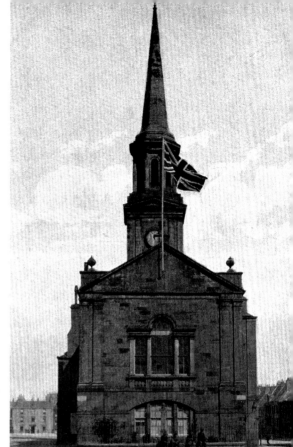

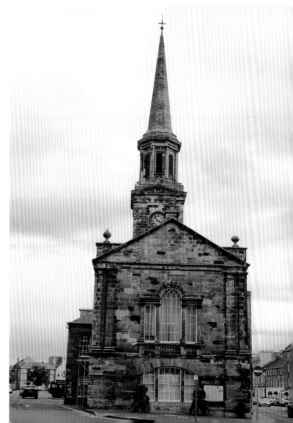

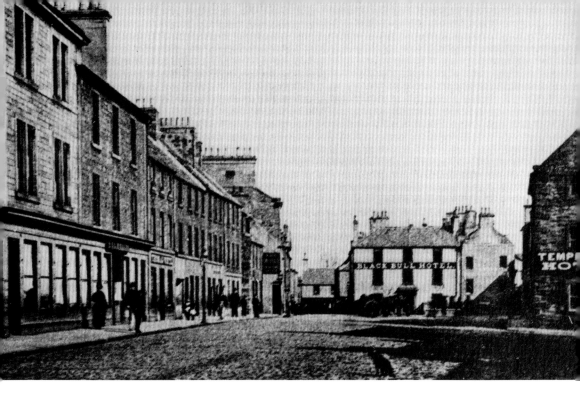

Market Street, Looking East
The Black Bull hotel and Temperance Hotel are prominent in the older image of Market Street, which was formerly known as Back Street.

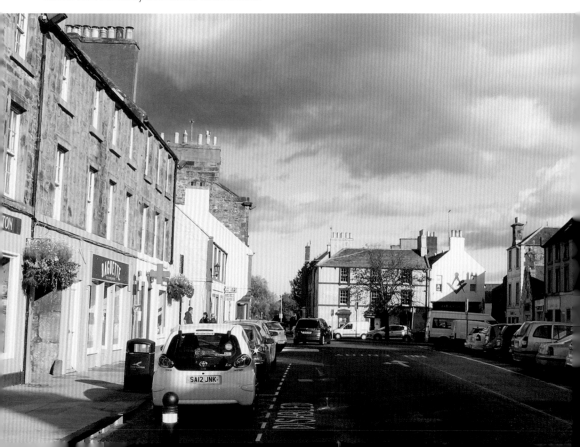

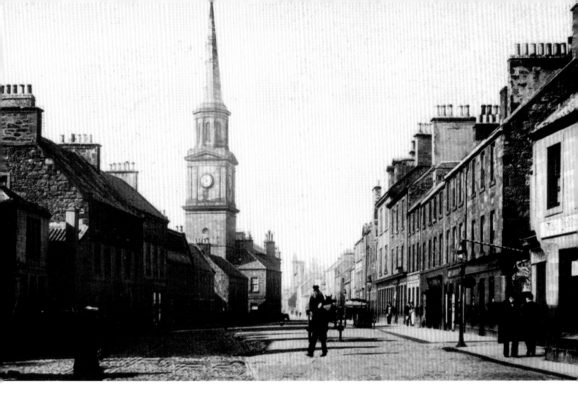

Market Street, Looking West
The changing scene in Market Street is shown in these images from the 1900s and the present day.

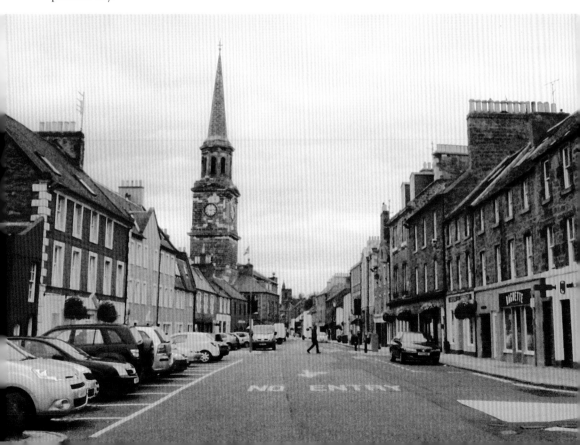

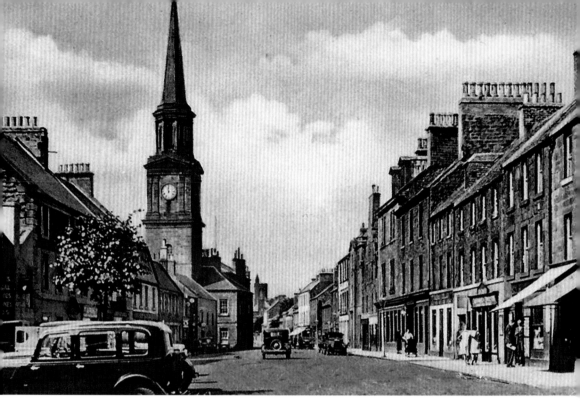

Market Street, Looking West
These two postcard views of Market Street date from the 1930s. Buildings on the left of the images were destroyed in a German air raid in Haddington on 3 March 1941. The site lay as a gap site for many years until it was redeveloped as flats.

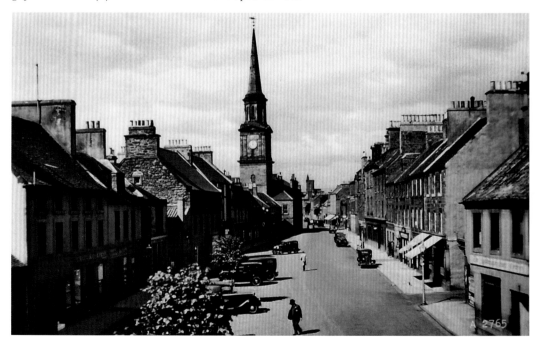

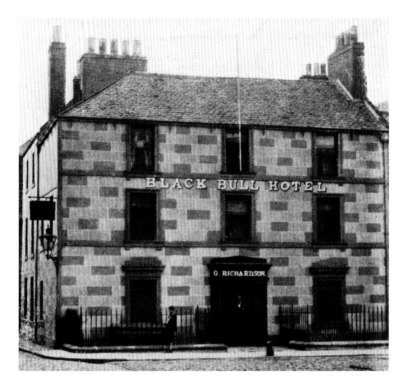

Black Bull, No. 73 Market Street

In 1910, George Richardson, the proprietor at the time, advertised the Black Bull as offering 'first-class accommodation with comfortable bedrooms, hot and cold baths all at moderate charges'. The pub was known as The Pheasant in more recent years. It closed in 2009 and remains disused at the time of writing.

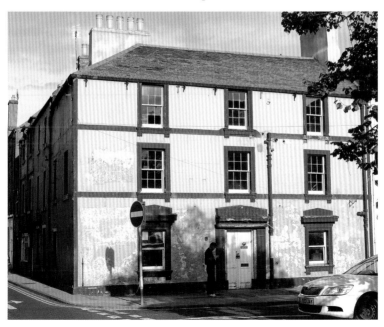

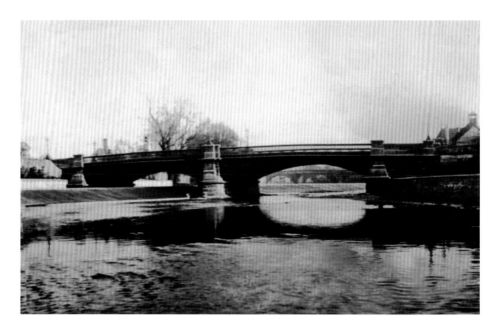

Victoria Bridge

The *Scotsman* reported that Haddington held a high holiday on 24 May 1901 on the occasion of the opening of the Victoria Bridge by the Earl of Haddington. It had long been recognised that the ancient Nungate Bridge was unsuitable for the traffic of the time and, in 1898, plans were approved for the new bridge. The bridge cost £9,237 to build, which was paid for by the town council, voluntary subscriptions and, rather surprisingly, the proceeds of a bazaar. Montgomery & Co., the owners of the Bermaline Maltings, gave the ground free of charge and built the approach roads.

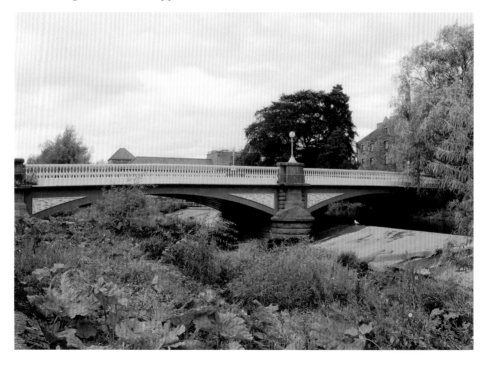

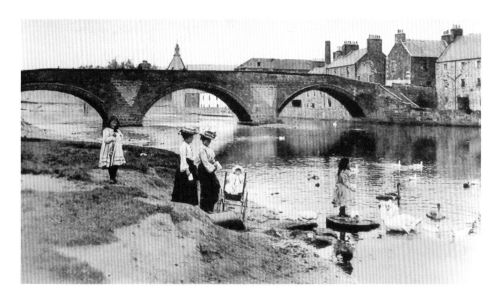

Nungate Bridge

The three sandstone arches of the picturesque Nungate Bridge span the Tyne, linking the east side of Haddington to the once separate barony of Nungate. There has been a crossing of the Tyne at the site of the Nungate Bridge since the thirteenth century. The current stone bridge has been much altered over the decades, but is believed to date from the sixteenth century, possibly after the Siege of Haddington in 1548 when the older bridge was destroyed – making it one of the oldest bridges in Scotland. Stones from the parish church were used to repair the bridge in 1659 and the gradient on the east side was lowered in the eighteenth century. The bridge has stood the test of many floods over the centuries, which is a testament to the quality of its stone and the historic workmanship. The gradient of the bridge was too steep and its width too narrow for heavily laden carts, which took advantage of the shallows of the ford just upstream of the bridge.

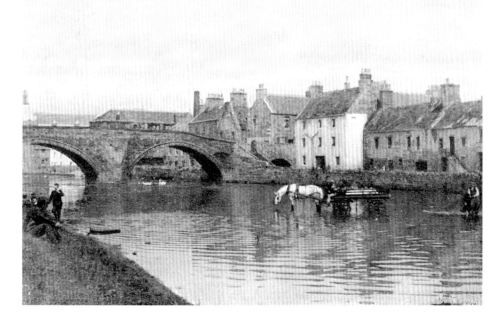

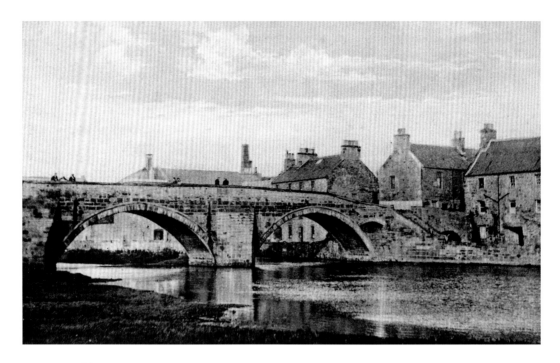

Nungate Bridge

The Nungate Bridge was retained for foot traffic after it was superseded as the main link over the Tyne by the opening of the Victoria Bridge in 1901. The iron hook on the western arch of the bridge was used for hanging criminals. The last time the hook was used was after Bonnie Prince Charlie's rising in 1745, when the hand of one of his supporters was hung there. The bridge was the venue for battles between the Haddington and Nungate youths. The old rallying call of the Haddingtonians before a clash was: 'Ye Nungate cuds, cock up your fuds, An' let the Haddington's bye; We'll drive ye east wi' bickering thuds, Until ye're tired and dune glad lye.'

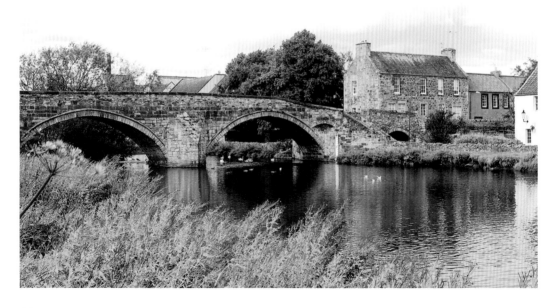

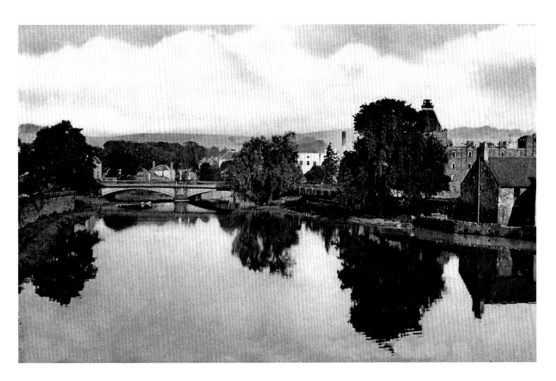

View from Nungate Bridge

The view of the Victoria Bridge from the Nungate Bridge. 'Nungate was once a jewel of rare excellence. Miry and malodorous, dirty and disreputable, it was yet the very image of the old Scots town of centuries ago. It was crammed with every feature of old Scots architecture.'

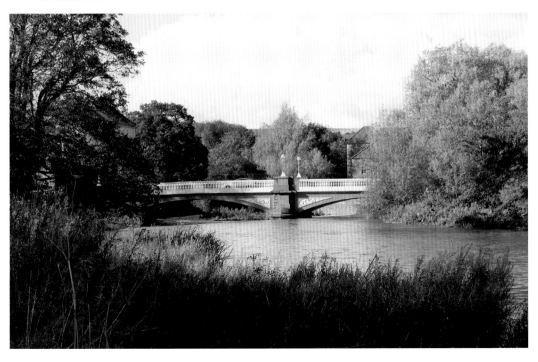

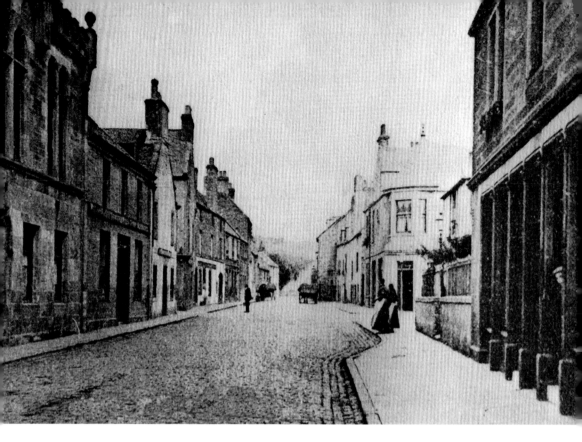

Hardgate

This area was dramatically altered with the construction of the Victoria Bridge in 1901. A large number of buildings were demolished to allow Victoria Terrace to extend through to the new Victoria Bridge.

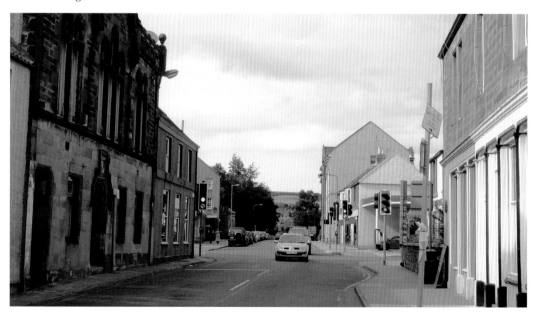

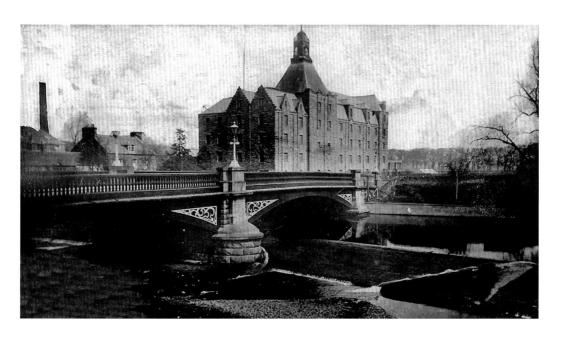

Bermaline Maltings, Whittingehame Drive

The large, red-brick factory on the bank of the Tyne dominates the east end of Haddington. It dates from 1898 and was built by the bakers Montgomery & Co. for the production of malted flour, which was made into Bermaline bread. The health-giving properties of the bread were emphasised in advertising – 'The Golden Bread for Glowing Health'. The factory would have employed many people and the inclusion of a clock tower would have been useful at a time when few workers would have possessed watches or clocks. Production of Bermaline bread ceased in 1970, although the building is still in use for flour milling. This continues the long association of the Gimmersmill area of Haddington with milling.

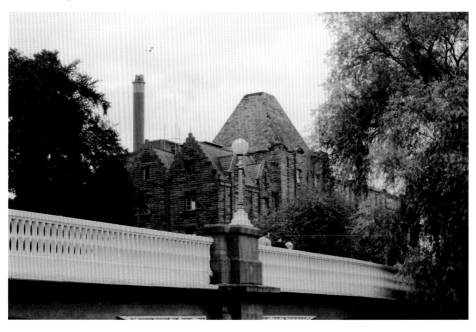

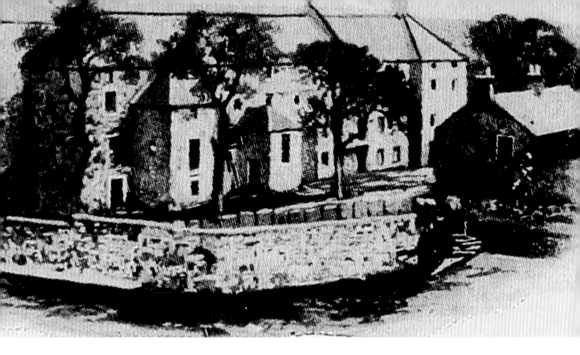

Gimmers Mill

Gimmers Mill was established by Cistercian monks in the twelfth century and has been used as a mill for centuries. The Gimmers Mill Bridge was built by the owners of Gimmers Mill to provide access to the mill around 1850. It stood downstream from the Victoria Bridge; it was a rickety affair and was demolished in 1901 on the opening of the Victoria Bridge.

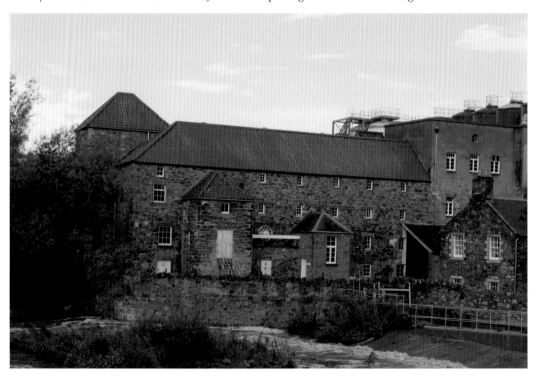

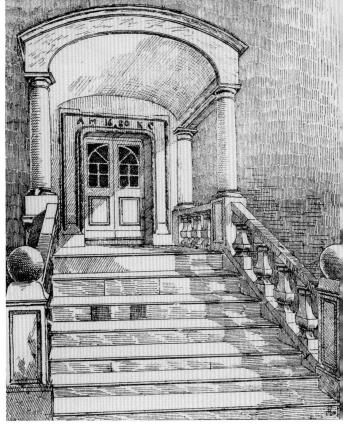

Haddington House Porch

The elegant porch at the front of Haddington House has a stone lintel with the date 1680 and the initials A. M. and K. C., which stand for Alexander Maitland and Katherine Cunninghame. Date stones acted as a prominent symbol of union through marriage and social standing.

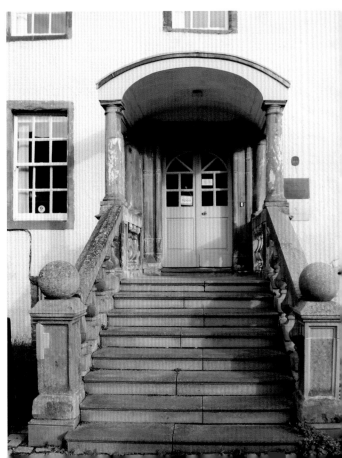

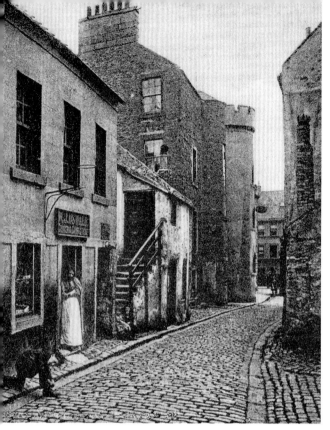

Brown Street

The older image shows Brown Street around 1900, with the grocery shop of N. J. Oswald and older houses with forestairs. The turret of the George Hotel can be seen at the far end of the street. Little remains of the old cobbled street which was truncated at its north end to allow the widening of Market Street. Brown Street takes its name from Samuel Brown, who was provost of Haddington in 1834 and ran an ironmongery shop in the town. Samuel was a son of the famous Haddington-based theologian Revd John Brown. John was born in Perthshire in 1722 to poor parents. He worked as a shepherd in his early youth after the death of his parents, and later as a peddler, schoolmaster and soldier. He was self-educated and became so adept in the classical languages that he faced suspicion that he had a Faustian pact with the Devil. His remarkable abilities secured him acceptance for theological training and, in 1751, he was ordained as minister of the Secession Church in Haddington. Revd Brown worked tirelessly during the thirty-six years that he ministered for his Haddington congregation. His most important work was *The Self Interpreting Bible* (1778), which helped make the Bible more accessible and encouraged family learning, though, his 1758 publication, *A Help for the Ignorant*, also sounds like a useful read. Brown's renown was such that Burns mentions him in the poem 'Epistle to James Tennant': 'My shins, my lane, I sit here roastin' Perusing Bunyan, Brown and Boston'. John Brown passed away at the manse of the Associate Synod in Haddington, on 19 June 1787 and was laid to rest in Haddington churchyard.

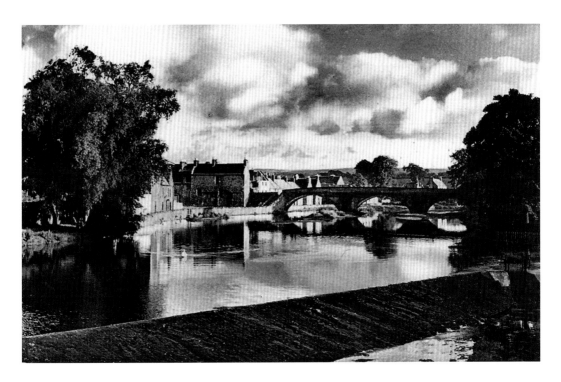

Gimmers Mill Weir

The weir controlled the flow of water to the Bermaline Maltings. When Montgomery & Co. took over the maltings in 1897, the weir was virtually useless due to silting of the river and they had to carry out a programme of dredging to get it back in working order. The earlier image shows the Tyne flowing under the western arch (to the right of the images) of the Nungate Bridge. The width of the river is now more restricted and the river runs under only two of the arches.

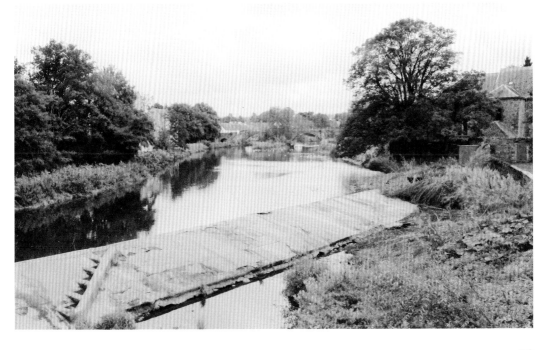

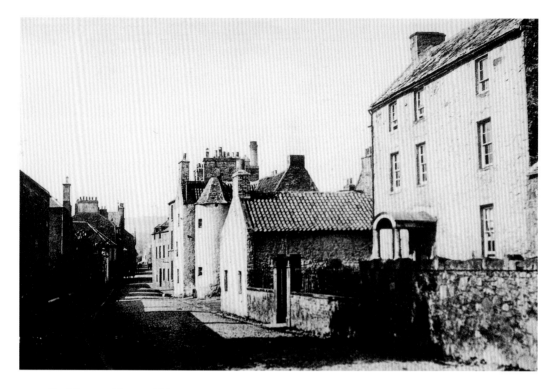

Haddington House, Sidegate

The seventeenth-century Haddington House is one of the oldest domestic buildings in Haddington (in the foreground of the images). It was built by Alexander Maitland on the site of an earlier medieval house and was restored in 1970 by The Lamp of Lothian Collegiate Trust. The ground at the rear of the house has been restored as a traditional seventeenth-century garden. The older image shows other historic buildings that have been lost to the remodelling of the street.

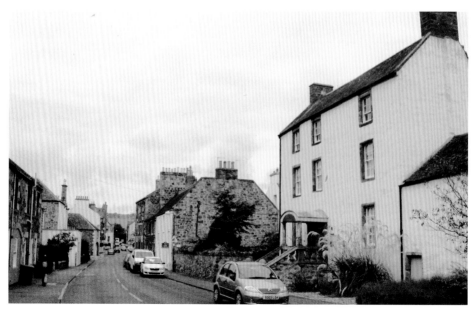

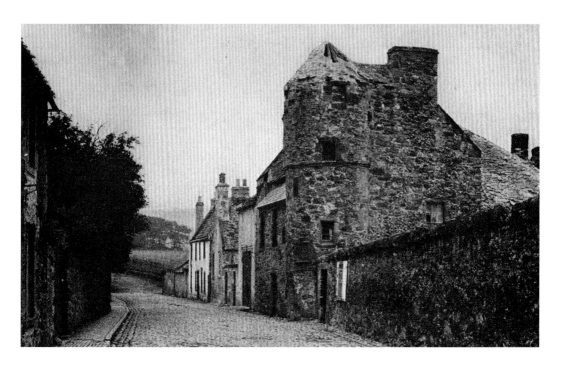

Bothwell Castle, Hardgate

The building with the circular tower on its corner in the older image was the sixteenth-century Bothwell Castle. It was a significant town house extending back to the river with a small central courtyard and dovecote. The building was originally known as Sandybed House and takes the name Bothwell Castle from the time when James Hepburn, 4th Earl of Bothwell, hid for several days from his enemies in the building after changing clothes with a female servant. In gratitude, Bothwell provided a yearly allowance of grain to Sandybed. Despite attempts to preserve and restore the building, it was demolished in the 1950s along with other parts of the original Hardgate for road widening. The curved section of wall in the new image is the base of the original tower. The site is now a public garden.

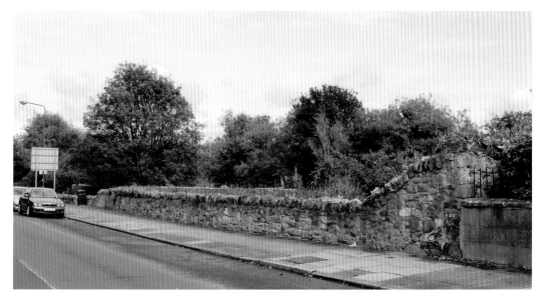

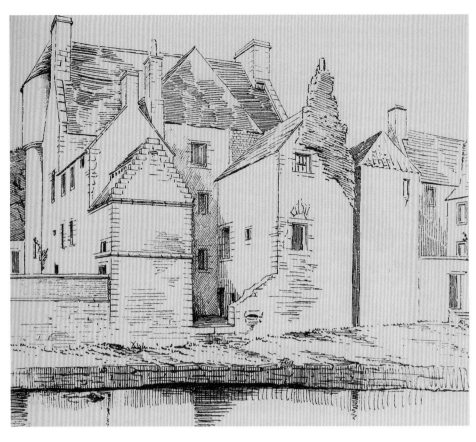

Bothwell Castle, Hardgate
Bothwell House from the river. The beautifully crafted line drawing is taken from the book
Castellated and Domestic Architecture of Scotland by David MacGibbon and Thomas Ross.

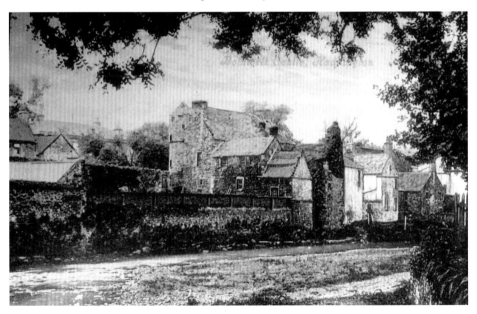

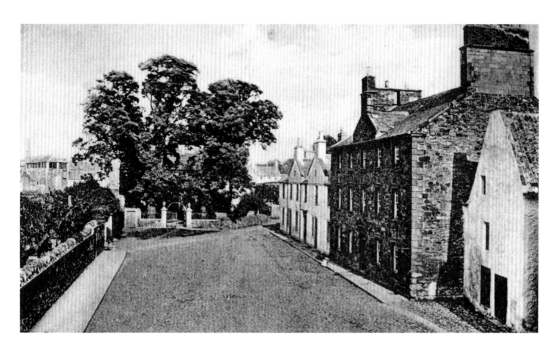

Church Street

The older image shows Church Street in 1905. The imposing symmetrical red sandstone building was custom built as the burgh school in the mid-eighteenth century (seen on the right), with Jane Welsh being one of its alumni. It faces the gardens of Holy Trinity Episcopal church. Elm House, which stands at the end of the street, can be clearly seen in the newer image due to the removal of the tree. Elm House dates from 1785 and was the site of the east port, a gate in the town wall. Church Street retains its stone setts, most of which were removed from the streets of Haddington, along with the gas lighting, in 1953 during redevelopment work in the town.

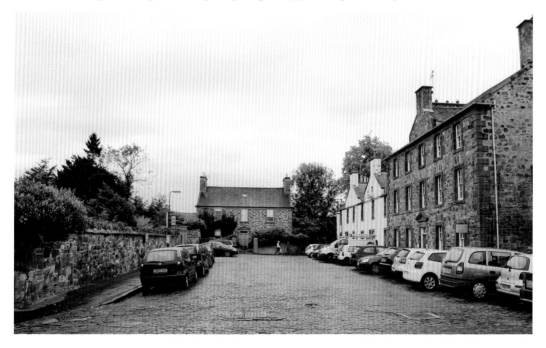

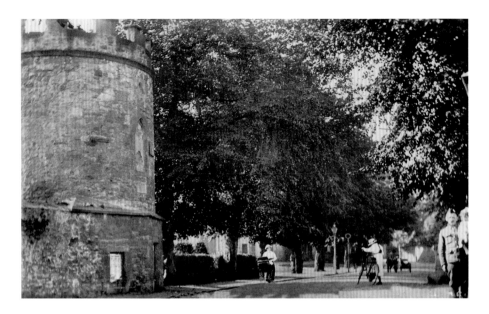

Lady Kitty's Doocot, The Sands

Lady Kitty was Lady Catherine Charteris. She was born around 1720, the daughter of Alexander, the 2nd Duke of Gordon and Henrietta, daughter of the Earl of Peterborough and Monmouth. The doocot (dovecote) dates from 1771 and Lady Kitty had it built as part of a walled garden. The doocot would have housed pigeons, which were a valuable source of year-round fresh meat. Their droppings which built up in the doocots, also made an excellent ferbliser and were used in the production of gunpowder. Their droppings, which built up in the doocots, also made an excellent fertiliser and were used in the production of gunpowder. There was also a belief that pigeons had medicinal properties and they were used in various forms as a cure-all for everything, from the plague to baldness. Doocots are often the only remaining residual reminder of a great estate, due to the superstition that their removal would result in a death in the family of the person responsible. The 'Sands' was the site of a major battle during the siege of Haddington in 1548. It was also latterly the site of the Ba' Alley, where a local type of ball game was played. The Normandy Remembrance Garden (to the right of the photograph, out of sight) was the location of a historic bowling green, one of the oldest in Scotland, recorded as far back as 1657.

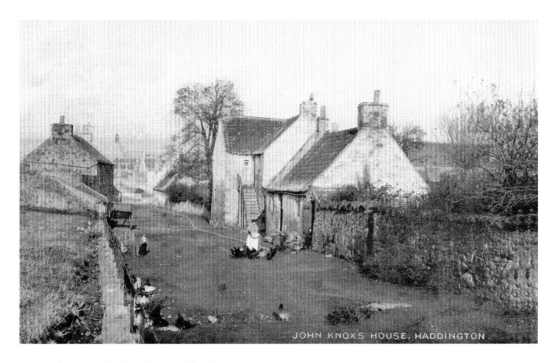

JOHN KNOX'S HOUSE, HADDINGTON

John Knox's Birthplace, Giffordgate

There is some doubt about the location of the birthplace of John Knox, the famed Scottish theologian. There are three main theories. The first places the location at Mainshill Farm in Morham, where generations of the Knox family had farmed. The second, at Gifford, is based on an early reference to Knox as Johannes Cnoxusn Scotus Giffordiensis, although this is very unlikely as there was no village by the name of Gifford at the time of Knox's birth. The third is at Giffordgate in Haddington. The old postcard of the Giffordgate is titled John Knox's House, although it is likely that the house was demolished in the early nineteenth century. The institute that took his name opened in Haddington in 1879 as a memorial to Knox.

John Knox's Birthplace, Giffordgate
Thomas Carlyle settled on Giffordgate as
the site of Knox's birth and had an oak tree
planted in commemoration. The plaque on
the site reads: 'Near this spot stood the house
in which was born John Knox AD 1505. In
commemoration an oak tree was here planted
29th March 1881 after the wish of the late
Thomas Carlyle.'

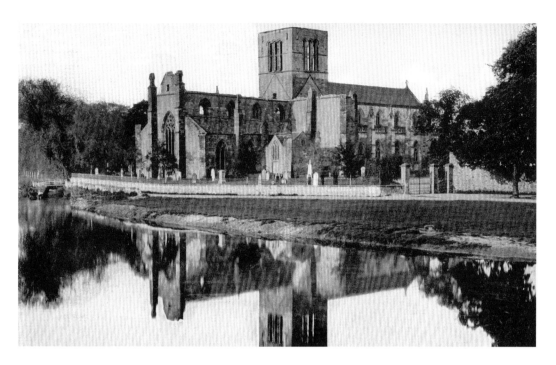

The Collegiate Church of St Mary the Virgin

St Mary's church sits in a tranquil setting on the wooded banks of the River Tyne. It is the largest parish church in Scotland, at 206 feet (62.8 metres) long, making it slightly larger than St Giles' Cathedral in Edinburgh and similar in scale to many smaller Scottish cathedrals.

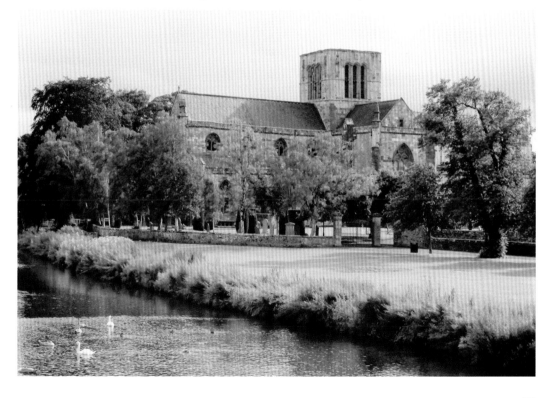

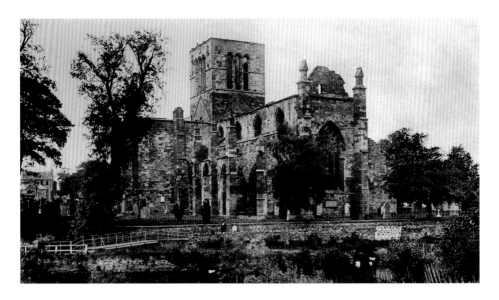

The Collegiate Church of St Mary the Virgin

The first record of a church on the site dates from 1139. This Norman structure would have been much smaller than the existing church. It was known as The Lamp of Lothian. The church was burnt down twice in the thirteenth century by English armies. In 1356, Edward III of England invaded Scotland and destroyed the church. Work began on the present church in 1380 and it took nearly a century to be completed. The scale of the building is reflected by the period of great prosperity in Scotland at the time of its construction. However, further destruction followed in 1548 when the English army occupied the town during the Siege of Haddington. Following the departure of the English army, only the nave of the church was usable for worship and the remainder of the building was left as a derelict and roofless ruin. There was some reconstruction work done in 1811, but the church was not fully restored until the remarkable conservation programme by The Lamp of Lothian Trust in the early 1970s.

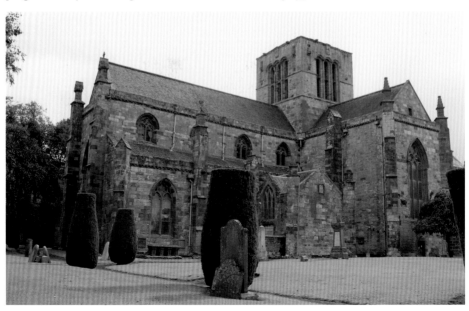

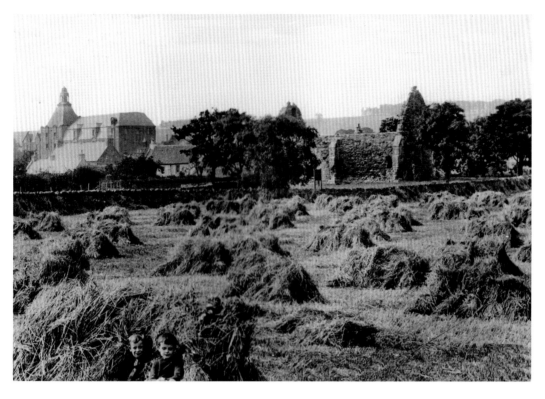

St Martin's Church

The roofless nave of St Martin's church in the Nungate stands on the eastern edge of Haddington. The building was originally a chapel maintained by the sisters of St Mary's Cistercian nunnery, which lay 1 km to the east as a place of worship for residents of Haddington. The nunnery was founded in 1178 by Ada, Countess of Northumberland, and was one of the largest in Scotland. St Martin's is all that remains of the nunnery and is a rare surviving religious establishment from the twelfth century.

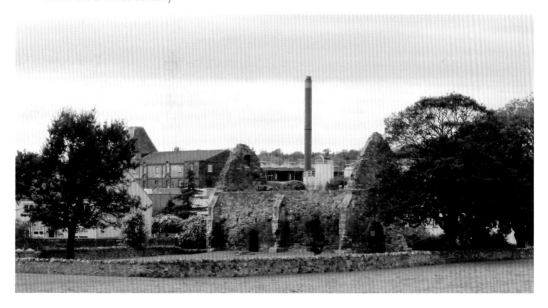

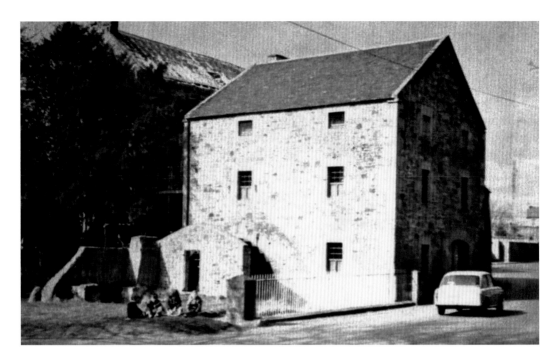

Poldrate Mill

Poldrate Mill, or the East Mill, was one of Haddington's three mills. It was water powered from a lake diverted off the Tyne and was built on the site of the earlier medieval Kirk Mill. The present mill, granary, maltings and workers' houses date from around 1842. The mill fell out of use in the mid-'60s and was converted into a community centre by The Lamp of the Lothian Trust. The landmark chimney was removed, but the mill wheel was preserved as part of the conversion.

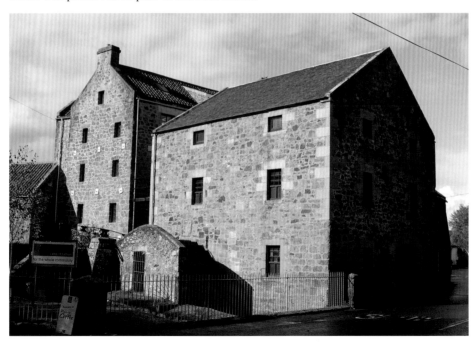

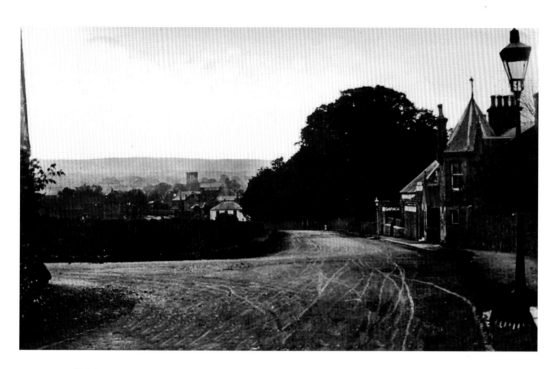

Goatfield, Dunbar Road

There has been some improvement in the road surfaces at this junction on the Dunbar Road in the 100 years between the two images. This was the site of a toll on what was the main turnpike road between Edinburgh and London, and the single-storey building (out of view to the left of these photographs), was the toll house. Turnpike acts authorised tolls to be paid by road users, with the income going towards the cost of improving and repairing the roads. The turnpike was the barrier that closed the road until the toll was paid. Goatfield is said to derive its name from the local Goat Burn.

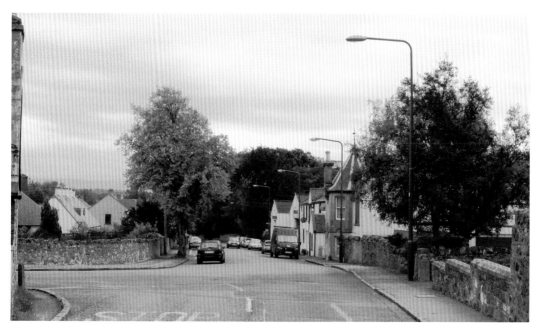

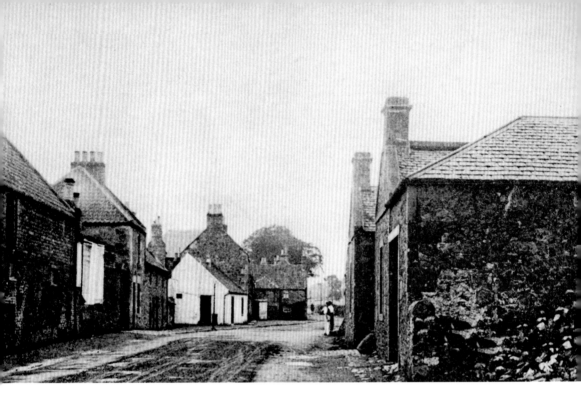

Rosehall

The older image shows the site of Haddington's gasworks in the right foreground that were removed in 1963. At the far end of the street was the Rosehall Foundry. Most market towns would have had a small foundry from the nineteenth century onward for the production of iron goods for agriculture, business and the home.

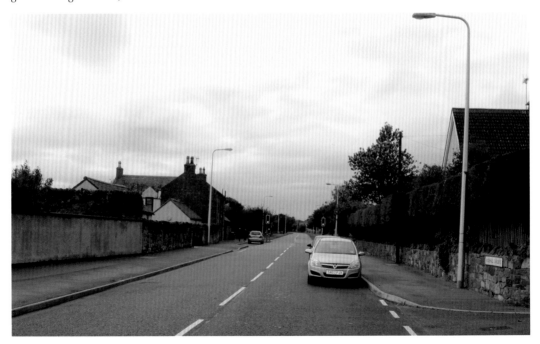

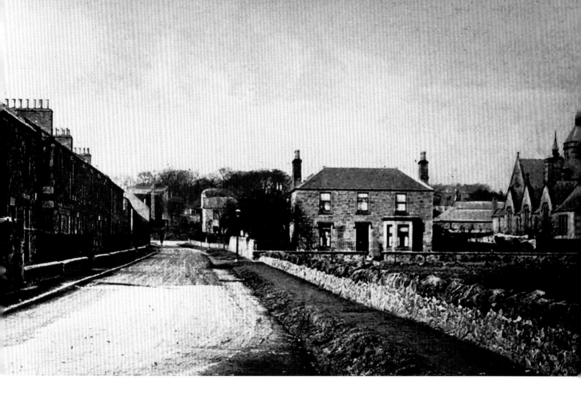

Meadowpark

The older image shows Meadowpark Road from around 1910. The back of the John Knox Institute and vestiges of Mylds Burn, running beside the pavement, can be seen in the older image. The 1819 plan of Haddington shows the Rosehall Toll at the north end of Meadowpark Road; this was replaced by the town gasworks in 1836.

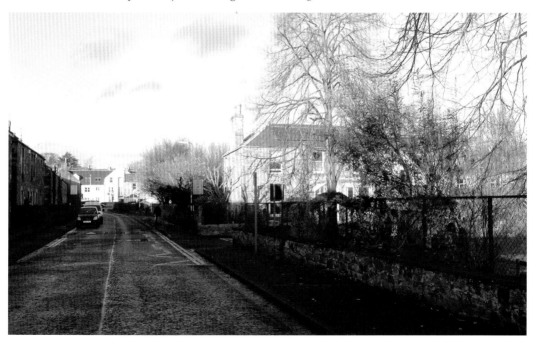

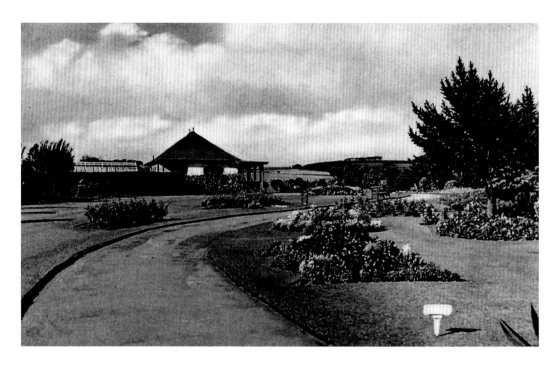

Neilson Park

Neilson Park is a green haven just to the south of the high street. It is an important outdoor leisure facility with a recreation ground, a play area for children and ornamental flower beds. George Neilson was a prosperous local shopkeeper. When he died in 1897, he bequeathed a sum to the community of Haddington. This was used to establish Neilson Park, which was ready for visitors by 1910.

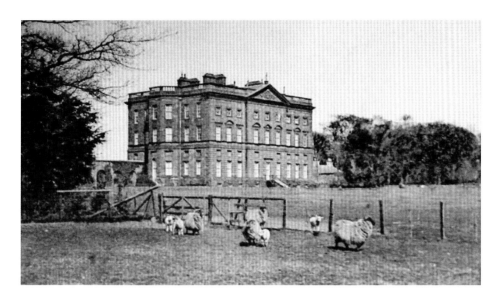

Amisfield House, Amisfield Park

There has been a substantial house on the Amisfield Estate since before the seventeenth century. The most recent magnificent red-sandstone Palladian mansion was completed in 1755 for Francis, the 7th Earl of Wemyss, and his wife, Lady Catherine Charteris Wemyss. It has been described as the 'most important building of the Orthodox Palladian school in Scotland'. Francis Wemyss had inherited the estate on the death of his grandfather, Col Francis Charteris (1675–1732), a notorious gambler and libertine – described by Jonathon Swift as 'a most infamous, vile scoundrel'. In 1730, he was tried and sentenced to death for raping a servant, in a case that created a media frenzy. Remarkably, he was pardoned by King George II and died from natural causes in Edinburgh in 1732. He was viewed with such opprobrium that his coffin was attacked and dead cats were allegedly thrown into his grave at Greyfriars kirkyard. Amisfield Park was used as a military training camp throughout the First World War and a prisoner of war camp in the Second World War. The estate started to decline in the nineteenth century and the house was demolished in 1928. Much of the original estate is now Haddington Golf Club, and the clubhouse stands on the site of the original house. There is mention of golf being played at Haddington in the burgh records as early as 1576. Haddington Golf Club was established in 1865 and played at Amisfield Park. In 1881, the club moved to a nine-hole course on the Garleton Hills, until the return to Amisfield, following the demolition of the house.

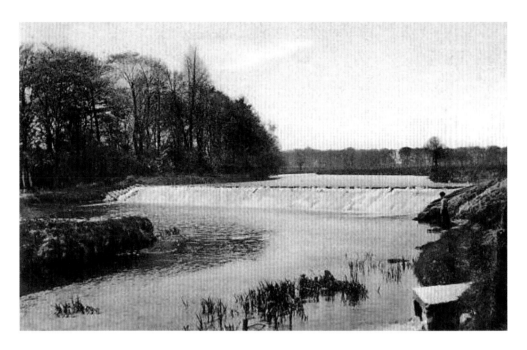

Amisfield Park Cascade

The tall, stone weir, with its stepped profile, spans the River Tyne to the north of Amisfield Park. It was reputedly the site of the Newmills Scottish Cloth Manufactory between 1681 and 1712, which was one of Scotland's first major industrial sites. The River Tyne was diverted so that it was further away from the house during the construction of Amisfield House in the eighteenth century and the present cascade was built at that time as a landscape feature.

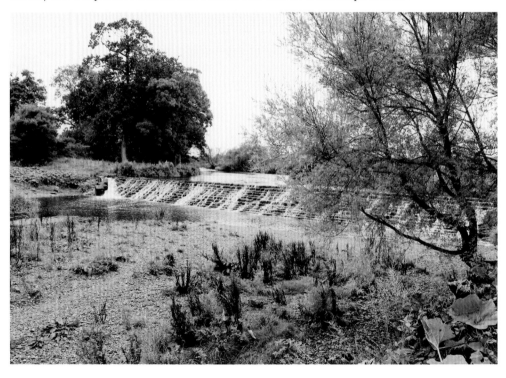

War Memorial

The Haddington Burgh and Parish War Memorial was unveiled by the Earl of Wemyss and March, lord lieutenant of the county on Saturday 3 September 1921. Businesses closed and the town's bells were tolled as a long procession passed through the streets on the way to the cemetery. At the ceremony, the Earl said that the memorial 'looked upon a world that was dark, troubled and distracted' – a reference to the national miners' strike of 1921. The strike started at the end of March after the mine owners reduced the wages the miners received when the pits were nationalised during the war. The Earl went on to say that he believed that 'when the history of the time was written the historians would not dwell on the discontents and on strikes, but rather on the fortitude with which the people of the country bore themselves through hard times'. The Earl also unveiled a brass plaque in the church in memory of the officers and men of the 8th Battalion Royal Scots (to which the East Lothian Territorials were attached), who fell in the war. The memorial is 20 feet high and the *Scotsman* described it as 'taking the form of a fifteenth-century cross'. Two eminent men of the time were involved in the memorial's design and construction – the architect, George Washington Browne, and the sculptor, Charles D'Orville Pilkington Jackson. Haddington was a centre of military activity during the First World War, with large numbers of personnel stationed in the town and fields to the west turned into practice trenches. There are 130 names of Haddington officers and men from the First World War on the memorial. The multiple inscriptions of the name Cranston on the memorial reflects the great sacrifice that one Haddington family made during the conflict.

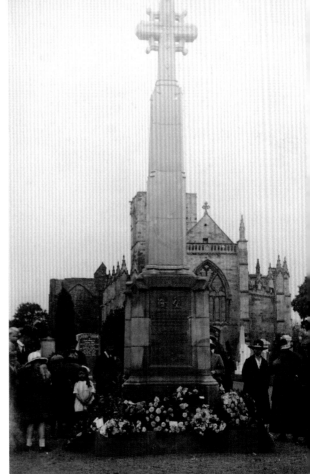

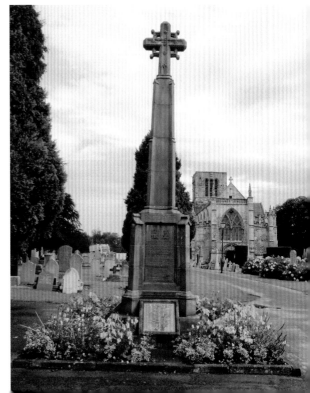

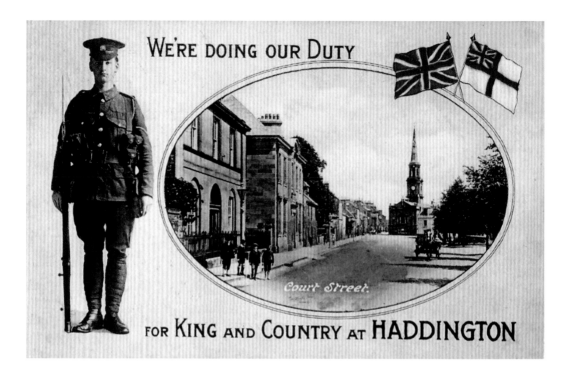

WE'RE DOING OUR DUTY

Court Street.

FOR KING AND COUNTRY AT HADDINGTON

Doing Our Duty

A group of soldiers take a break on the Plantin Road in the Garleton Hills during training in 1914. It is likely that the soldiers were bound for the rifle ranges at Kae Heughs, to the north of the Garleton Hills. Three ladies can be seen out for a stroll in the background. The postcard from the First World War, which shows a fully kitted young soldier and an image of Court Street, was probably intended for messages sent home by the many soldiers billeted at Haddington.

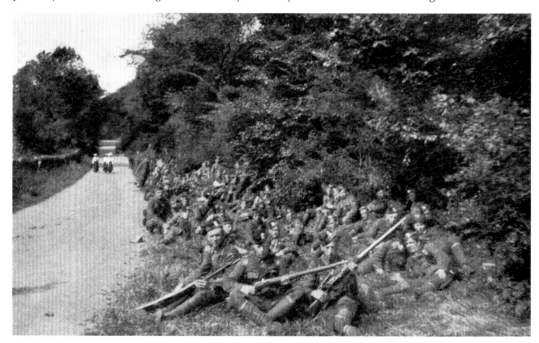

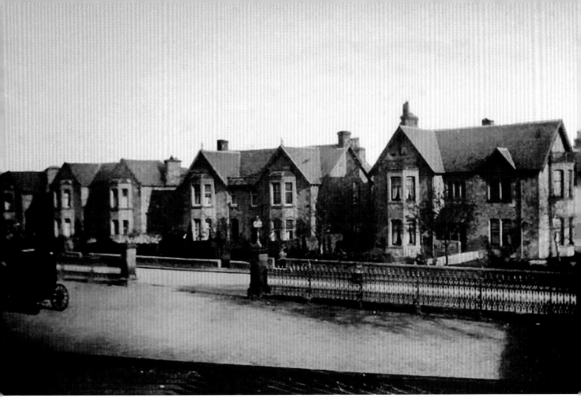

West Road

The carriage entrance to Haddington Railway station can be seen in the foreground of the image above. The boundary wall has been stripped of its elaborate ornamental railings and lamps, with only the gate piers remaining. The area is now a small landscaped space.

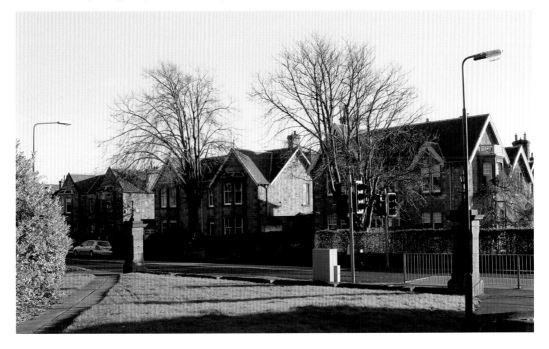

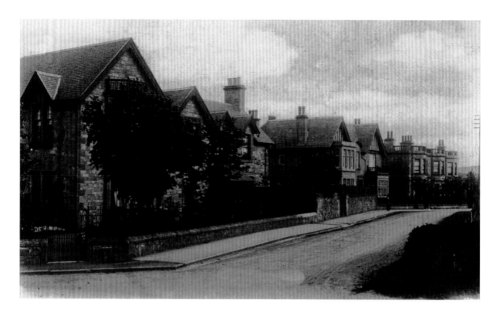

Letham Drive

The substantial Victorian villas on Letham Drive at the west end of Haddington are virtually unchanged in these two images, which are separated by over 100 years. The iron railings would have been removed for the war effort in the 1940s. Railings and gates were removed throughout the country during the Second World War following a direction by Lord Beaverbrook, the Minister of Supply. There is some debate about what happened to them after they were removed. It is claimed that the metal was unsuitable for reprocessing and that they were dumped at sea. There are stories that there was so much offloaded in parts of the Thames that the vast quantity of iron disrupted ships' compasses. It is also claimed that they were used as ballast in ships, with many houses in African seaports being festooned with fine Georgian railings salvaged in the destination ports. The removal of so much ornamental cast iron was a great architectural loss. However, even if they never became guns and tanks, it was seen as a morale-boosting exercise.

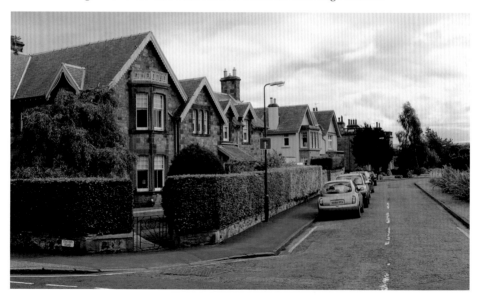

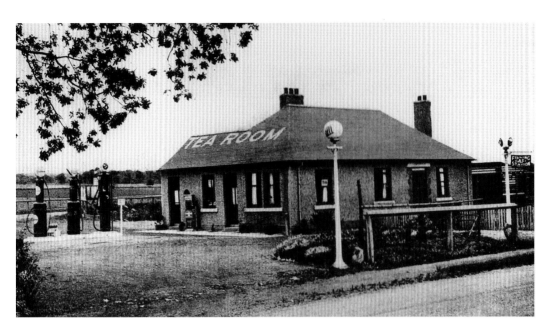

The Oak Tree Café, Gateside

The Oak Tree Café occupied a site to the west of Haddington at the junction of the old A1 and the west road approach to Haddington. It was built in 1932 and was originally known as the Letham filling station. The name was changed to the Oak Tree Café in the late 1940s after a change in ownership. It was a petrol filling station as well as a café and must have provided a restful break for many a weary traveller. Bypass roads resulted in its closure in 1994 and the site lay empty for many years until its demolition in 2008.

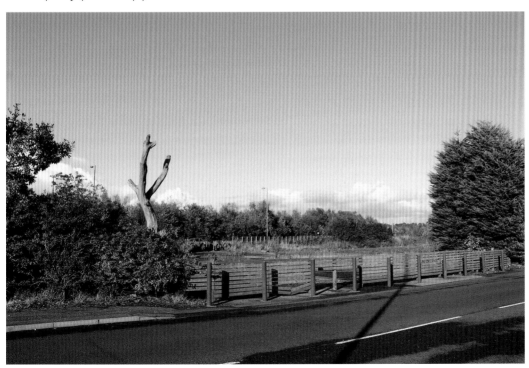

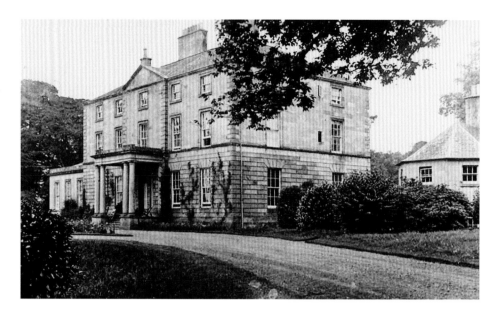

Alderston House

Alderston House, on the north-west outskirts of Haddington, is a small mansion which was erected in 1788 and at one time was known as Smeaton Park. Alderston was the family estate of the Steuart family. Robert Steuart (1806–43) was MP for Haddington during the 1830s. Steuart is described as 'a tall, dark, commanding figure, with an abundant crop of hair and partial to large whiskers'. He was appointed as a diplomat to Colombia in 1841, where he died of fever in July 1843. Alderston House had a variety of uses in the twentieth century, including a convalescent home for the Scottish National Benevolent Association, a nurses' home and council offices. At the time of writing, there are proposals for its conversion to a crematorium.

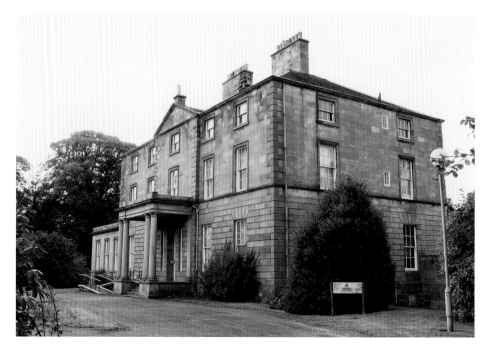

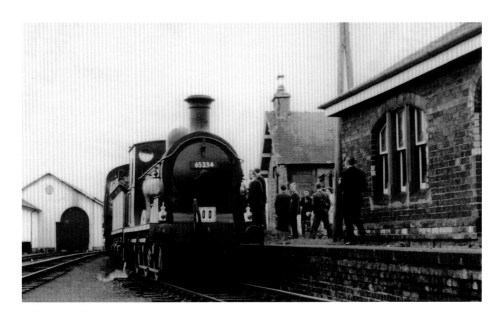

Haddington Railway Station

Haddington was served by a 5-mile branch of the East Coast Main Line from Longniddry between 1846 and the 1960s. The North British Railway originally intended that the east coast main line from Edinburgh to London should have a stop at Haddington. However, this would have been more costly than the route that was finally taken through Drem. The branch line was provided as compensation to the town. It is also said that the Horse Carriers were so powerful in Haddington at the start of the nineteenth century that their opposition prevented the main railway line passing through the town. The station ran into problems long before the Beeching rail cuts of the '60s. The torrential rains of August 1948 damaged the station so badly that it was considered hazardous to public safety. The line carried passengers until December 1949 and was used for freight until 1968. There are still clear signs of some of the original station buildings and platform, which are now occupied by a small industrial estate.

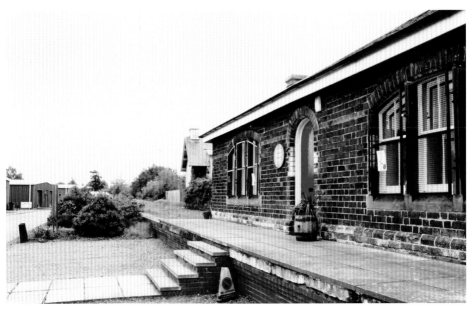

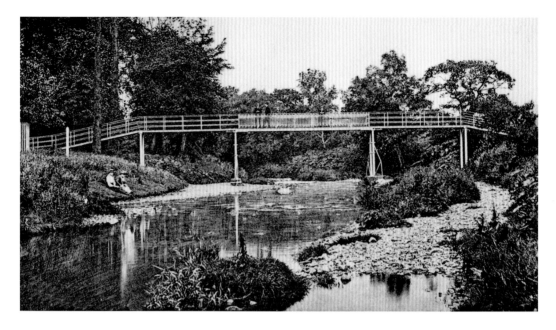

Stevenson Bridge

The East and West Haughs are the attractive grassy areas with fine trees to the north of the Tyne. Haugh is defined as a low-lying meadow in a river valley. The Stevenson Bridge is a useful footbridge that crosses the Tyne at the west end of the Haugh and links to a right of way to the Lennoxlove Estate. The original footbridge replaced an old stepping stone crossing. It is named after David Stevenson who was Provost of Haddington on four occasions in the 1870s and 1880s and campaigned for its construction. It is named as the Chinese Bridge in a map from 1822.

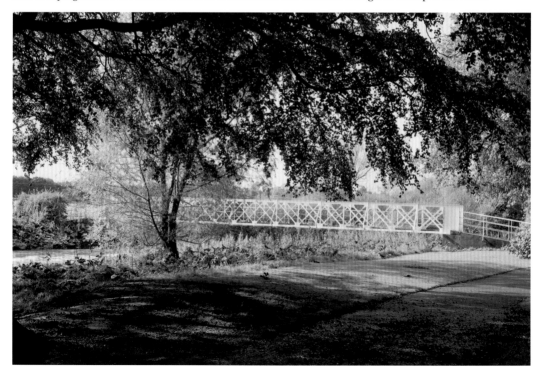

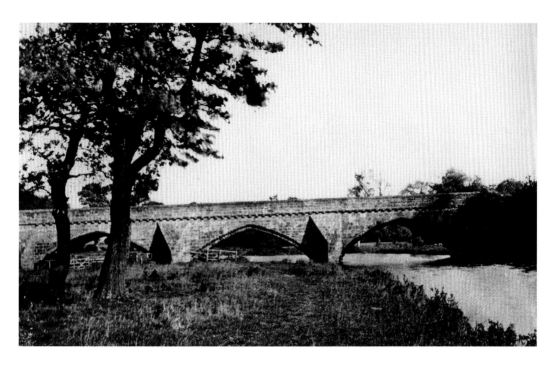

Abbey Bridge

The three pointed arches of the Abbey Bridge span the Tyne to the east of Haddington. The total span is 131 feet with a width of 16 feet. It can be dated to the early sixteenth century and is one of only a limited number of small medieval bridges that survive in Scotland. The bridge was financed by and takes its name from the abbey of St Mary's.

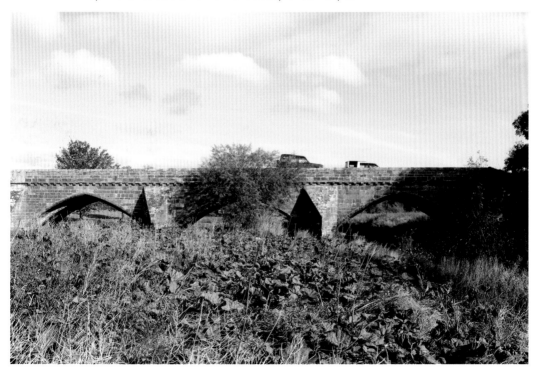

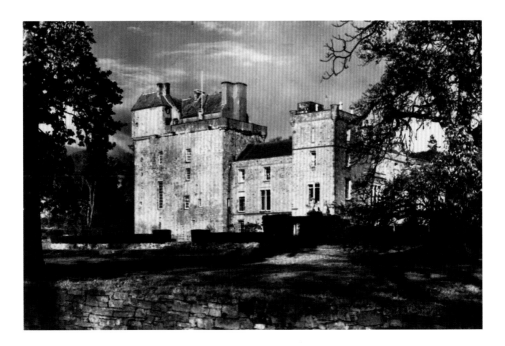

Lennoxlove

Lennoxlove House is located just to the south of Haddington. It is approached by a half-mile drive fringed with oak trees. It is 'one of Scotland's most ancient and notable houses'. The Lethington Estate was acquired in 1385 by the Maitland family, who built an L-plan tower house. Numerous additions and alterations were carried out over the centuries to create the present mansion. The name was changed from Lethington to Lennoxlove in 1703. There are a number of versions of the reason for the change of name. All relate to love stories and the rich and beautiful Frances Teresa Stewart, Duchess of Lennox, who was the model for Britannia on British coins. The extensive designed landscape around Lennoxlove was originally laid out in the mid-sixteenth century. One of the highlights is the seventeenth-century sundial in the shape of a rather vivacious young lady, with a seventeen-faced sundial balanced on her head.

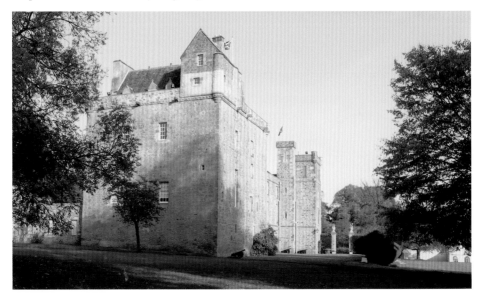

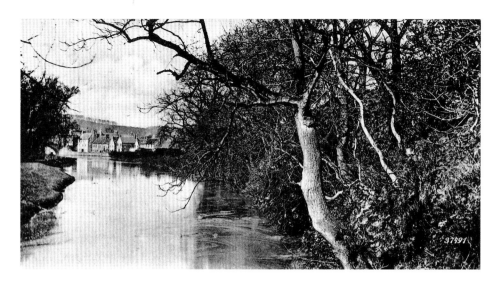

On the Tyne

The River Tyne has its source in the Moorfoot Hills in Midlothian and flows for around 30 miles to the sea just north of Dunbar. Haddington has a precarious relationship with the Tyne. The river was the source of power for the town's mills, which contributed to its economic prosperity, but it has also flooded the town on numerous occasions. In 1358, the Nungate convent came close to being swept away by floods. However, according to legend, it was saved when one of the nuns threatened to throw an image of the Virgin Mary into the flood unless the waters abated. On 4 October 1775, the river rose 17 feet in an hour. One of the worst events in more recent years was on 12/13 August 1948, when the waters rose so high that many families were left homeless and people had to be rescued by boat. The incredible height of the flood at the time is commemorated on a plaque on the Sidegate.

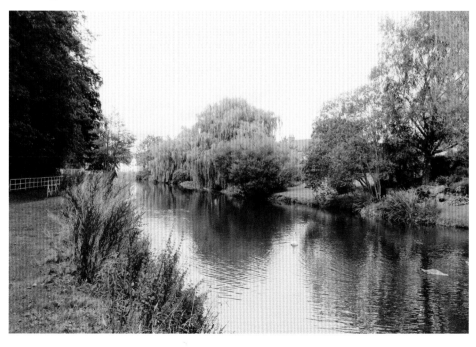

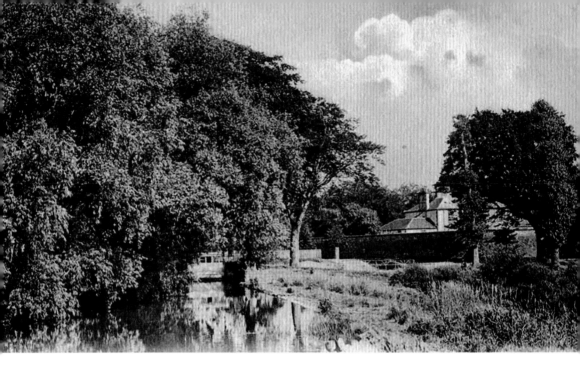

The Long Cram
The Long Cram is the name given to the stretch of the River Tyne to the south west of Haddington. The name may derive from the river backing up at this point in heavy rains. A curling pond once stood on the north bank of the Tyne near the Long Cram.

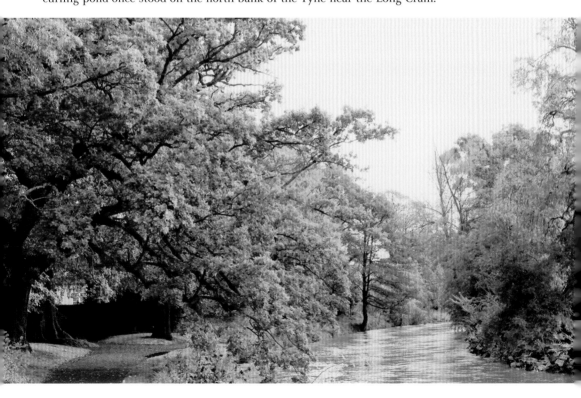

Coal and Candle

In 1598, there was a major conflagration in the town caused by a servant drying clothes too close to an open fire. In order to prevent repeats of this, the town council decided that the town crier should perambulate the main streets during the winter evenings, warning people to be cautious around fire. The ceremony was stopped in the mid-nineteenth century and had the name 'Coal an' Can'le,' from the following verses that the crier recited:

> A' guid men's servants where're ye be,
> Keep coal an' can'le for charitie!
> Baith in your kitchen an' your ha'.
> Keep weel your fires whatever befa,!
> In bakehouse. brewhouse, barn. and byre,
> I warn ye a' keep weel your fire!
> For oftentimes a little spark
> Brings mony hands to mickle wark!
> Ye nourrices that hae bairns to keep,
> See that ye fa' nae o'er sound asiecp,
> For iosing o' your guid renown,
> An' banishing o' this barrous toun
> 'Tis for your sakes that I do cry:
> Tak' warning by your neighbours bye!

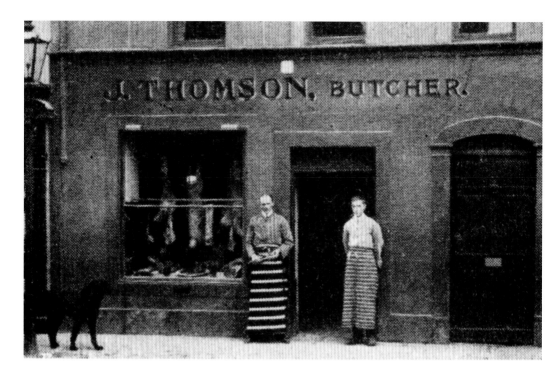

Haddington Shops

This section includes images of Haddington shops from advertisements included in the 1910 *Borough Guide to Haddington*. The guide notes that Haddington at the time 'possessed well-stocked and attractive shops of all kinds in which prices rule low, and the tradesmen are courteous and obliging'. The image above shows the premises of J. Thomson, at Nos 10–11 High Street, a flesher in 1910. Their speciality was pickled tongues. The dog in the picture looks quite fit and probably belonged to the butcher.

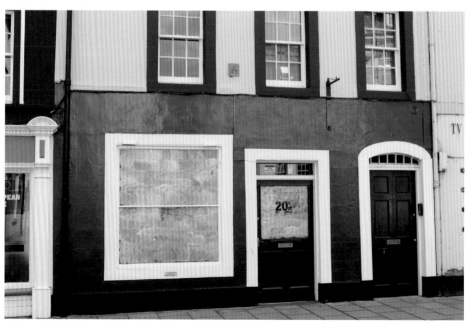

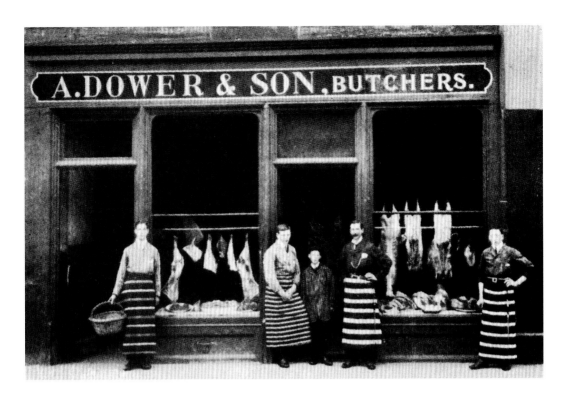

A. Dower & Son, No. 26 High Street
The butchers strike a pose outside A. Dower & Son, butchers and poulterers. The specialities of the shop were corned beef, pickled tongues, prime home-fed beef, mutton and salted rounds.

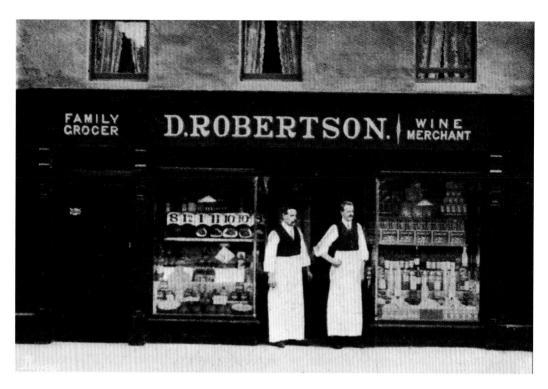

D. Roberston, Nos 27–28 High Street

In 1910, the shop at Nos 27–28 High Street was occupied by Robertson's Public Supply Stores. The shop provided 'groceries and provisions of the highest quality at moderate prices and a delivery service to any part of the district'.

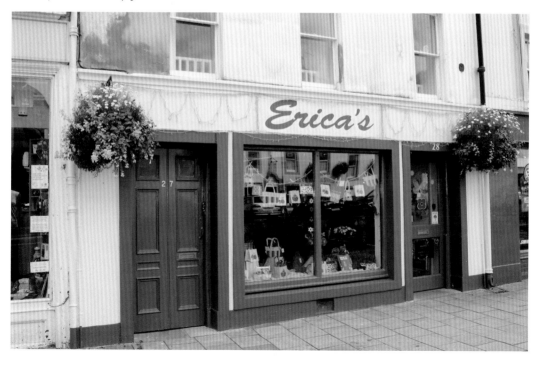

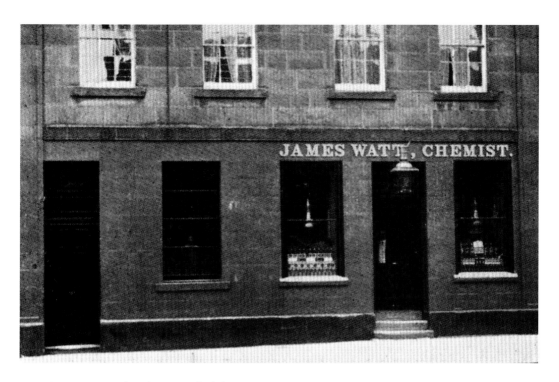

James Watt, Chemist, No. 36 High Street
The premises of James Watt, chemist, were established at No. 36 High Street in 1844. In 1910, the shop was advertised as being 'fitted up in the most modern and up to date style'. There was a night bell, indicating that the pharmacist, W. P. Wilson, must have lived above the shop.

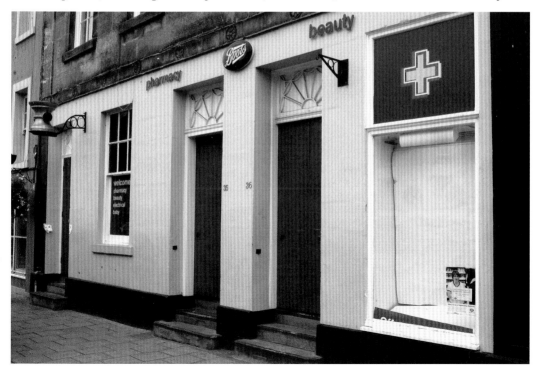

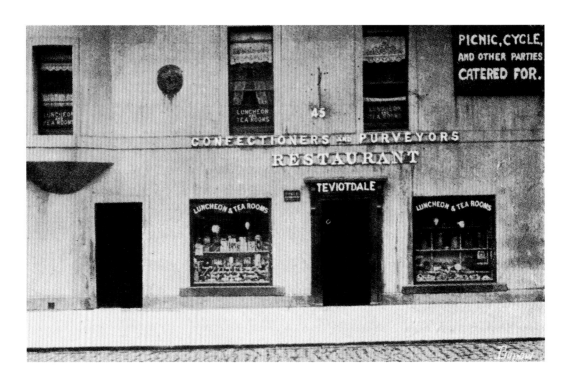

Teviotdale & Son, No. 45 High Street

In 1910, the restaurant of Teviotdale & Son provided breakfasts, luncheons, teas and dinners to picnic, cycle, soirée, ball, wedding, christening, birthday, dinner and supper parties. They offered a large and varied selection of tea bread, pastry, chocolate, jellies, creams and ices.

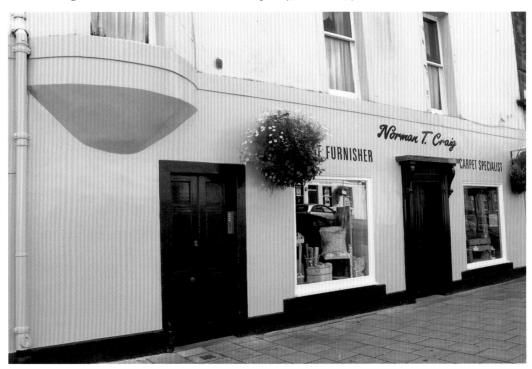

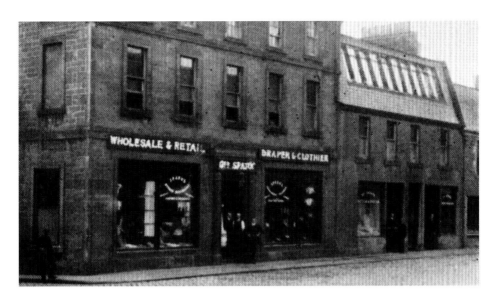

George Spark, Nos 57–60 Market Street

George Spark was a woollen merchant, draper and clothier, and advertised his premises in 1910 as being 'One of the Best Houses in the South of Scotland for variety of Goods and Standard Value.' Specialising in liveries for gentlemen's servants and ladies' tailor-made costumes, their tailoring, dressmaking, millinery and general outfitting was 'all done on the premises with taste, style, ability and moderate charges'. The buildings were completely destroyed in a German air raid on Haddington on 3 March 1941. The attack happened around 8.30 p.m. and caused three fatalities – a local man and two soldiers – with four others injured by shrapnel. Other buildings were lost and the raid cratered the roads, cut off gas and water supplies and made many residents homeless. The site lay as a gap site for many years until it was redeveloped as flats.

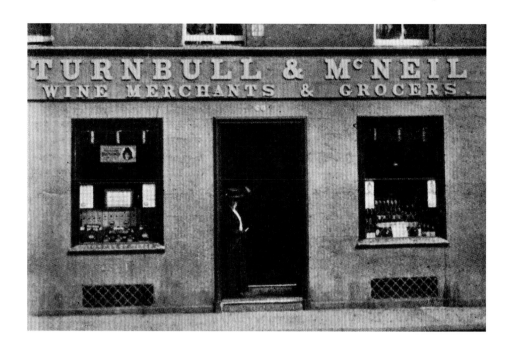

Turnbull & McNeil, No. 60 High Street

Turnbull & McNeil (established in 1792) were wine merchants and Italian warehousemen. They stocked pure Chinese, Indian and Ceylon teas, Vibrona wines, Hall's wine, Invalid stout and Wincarnis. Invalid stout was low in alcohol and was thought to be especially nutritious. Wincarnis is a fortified tonic wine made from grape juice, malt extracts, herbs and spices. It originally contained meat and takes its name from *carnis*, Latin for meat. It was originally named Liebig's Extract of Meat and Malt Wine and was advertised as 'the finest tonic and restorative in the world'. Wincarnis is now marketed as an aperitif. It remains popular in a number of countries, where it is taken by new mothers as a tonic. Hall's wine and Vibrona were other brands of tonic wine.

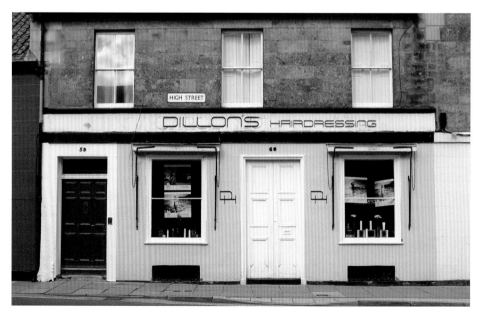

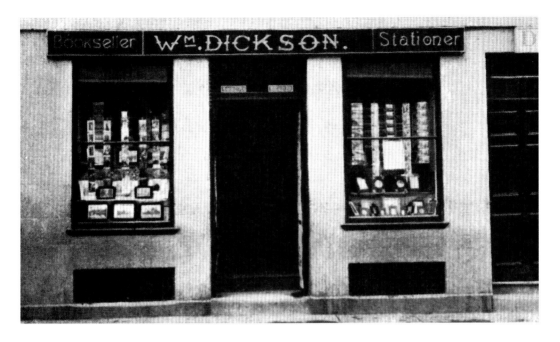

William Dickson, No. 61 High Street
William Dickson – bookseller, stationer and newsagent – advertised as the successor to Thomas Cowan's shop at No. 61 High Street. A large selection of current magazines, the latest novels, fancy goods and souvenirs for visitors were available. Newspapers were delivered in town twice daily.

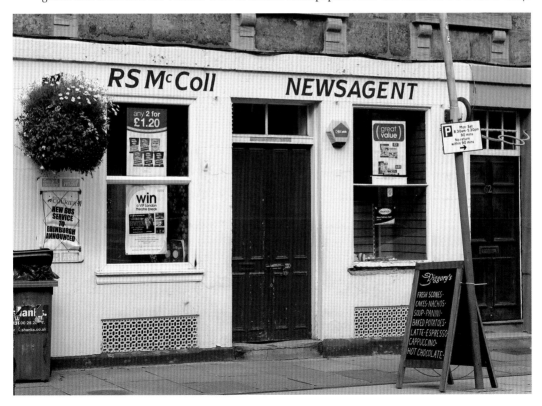

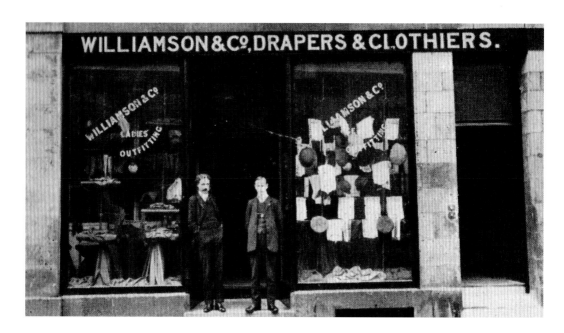

Williamson & Co., No. 64 High Street

Williamson & Co. were fashionable drapers and clothiers. They were agents for the famous Aertex Cellular Clothing. Aertex was developed by Lewis Haslam, a Lancashire mill owner, who established a manufacturing company in 1888. Aertex was a revolutionary material that was lightweight and also trapped an insulating barrier of air.

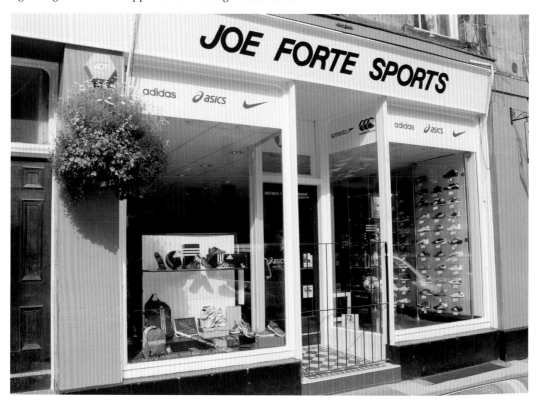

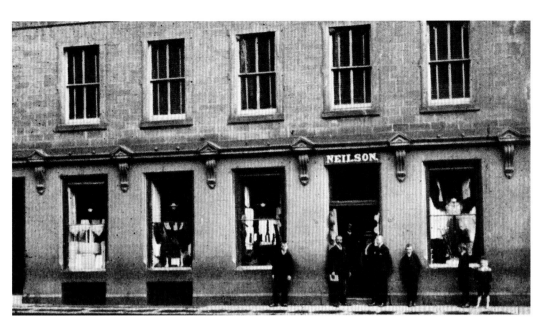

G. Neilson & Co., No. 67 High Street

G. Neilson & Co. was a general and fancy dress drapers, where everything was advertised as being new and up to date. They were agents for the new Viyella cloth. Viyella, a blend of wool and cotton, was the first trademarked fabric in the world. It was first registered in 1894, but must have taken a few years to reach Haddington, where it was still considered new in 1910.

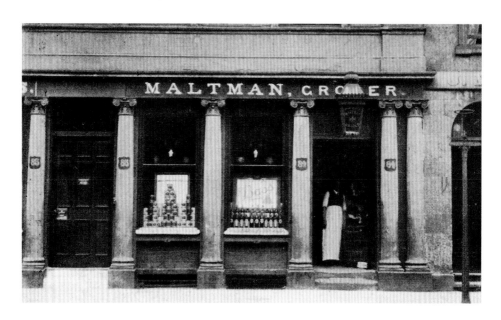

William Maltman, No. 84 High Street

William Maltman, established in 1827, was a wine merchant and family grocer. Their malt liquors were 'always in sparkling condition' and they supplied 'groceries, provisions, teas, freshly roasted and ground coffees at city prices'.

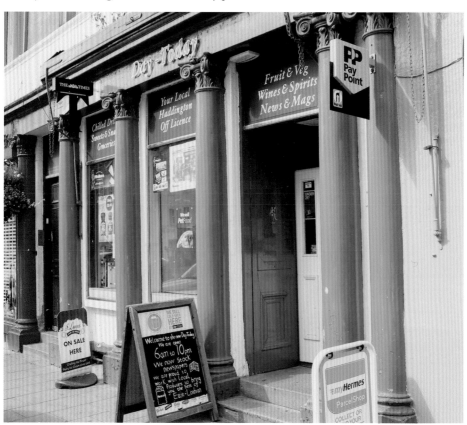

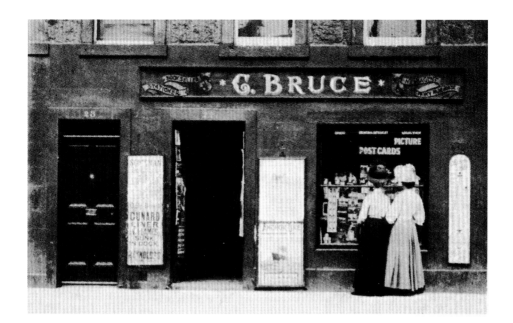

Charles Bruce, No. 22 Market Street

Two elegant ladies are seen window shopping at Charles Bruce – bookseller and stationer – at No. 22 Market Street (*above*). The shop offered plain and fancy stationery, pictorial postcards, magazines and periodicals, bookbinding, engraving, picture framing and artists' materials. Charles Bruce was a prolific maker of postcards of Haddington and the surrounding area, and many of the older images in this book are the product of the shop. The shop was also an agent for the Anchor Lines and Union Castle Shipping companies. The advert on the frontage reads 'Cunard Liner in Flames Sunk in Dock'. This refers to the RMS *Lucania* which was damaged by a fire and partially sank at the Huskisson Dock in Liverpool. This event dates these shopfront images to 14 August 1909.

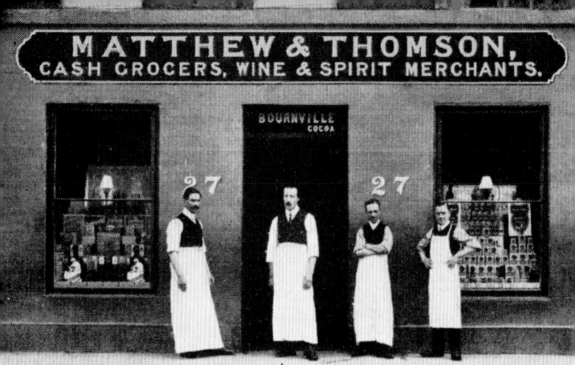

Matthew & Thomson, No. 27 Market Street
Matthew & Thomson were family grocers and tea, wine and spirit merchants. Their finest old Scotch whisky, which was 'Appreciated by the Public', retailed at *2s 6d* a bottle.

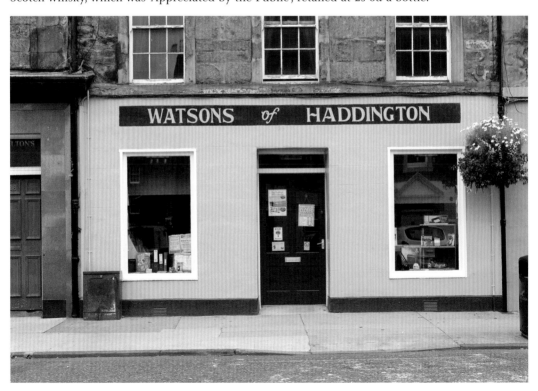

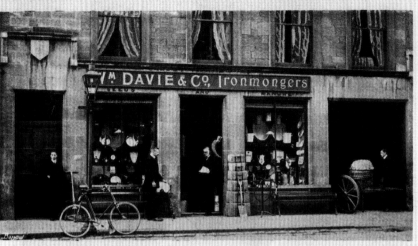

WM. DAVIE & CO. Wholesale and Retail General Ironmongers &c. 37, 39, 40, 41, Market Street, Haddington.

Sheep Dipping Materials.

Household Ironmongery.

Brushes Baths. Wringers Mangles

Mincers. Knife Cleaners.

Cutlery and Electro-plate.

Smiths' & Joiners' Furnishings.

Roofing Felts. Wire Netting.

Ropes. Twines. Sheep Nets.

Sporting Ammunition. Cartridges. Guns. Motor Spirits. Oils and Grease. Paraffin Lamps & Lanterns. Gig Lamps. Burning Oils. Kitchen Ranges, Room Grates & Stoves.

Paints and Oils.

W. M. Davie & Co., Nos 37–41 Market Street

W. M. Davie & Co. was a wholesale and retail general ironmonger. The advert from 1910 provides details of just some of the items they stocked for the home, for country pursuits and for local farmers.

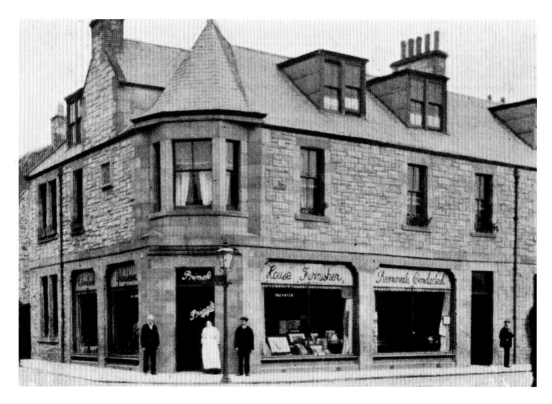

James Pringle, Victoria Terrace/Hardgate

The James Pringle shop at the corner of Hardgate and Victoria Terrace maintained a large stock of furniture for the dining room, drawing room, parlour, bedroom and kitchen. The shop was able to 're-do mattresses' as a same day service, repair old furniture and apply a French polish. Pringle's was first established in the premises in 1904. It was taken over by the local co-operative company in the late '30s. In March 1941, the building was completely flattened during an air raid by German bombers. The site lay empty for a number of years until it was converted for use as a petrol filling station.

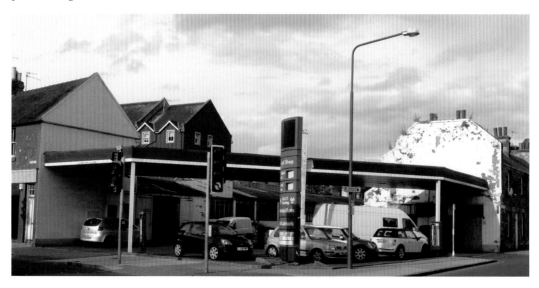

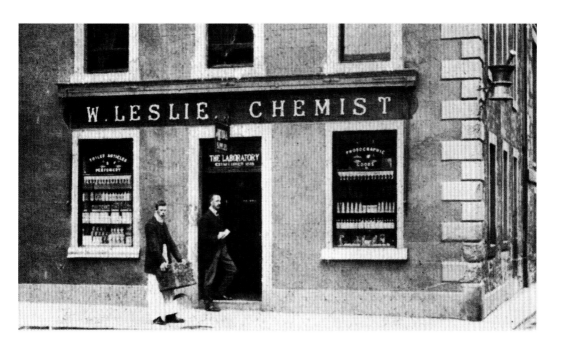

William Leslie, High Street

William Leslie, pharmacist and chemist, occupied the shop adjacent to the George Hotel in 1910. The shop advertised as 'taking the greatest care in the selection of pure drugs – with each prescription being duly checked'. They also had a photographic darkroom, stocked 'chemicals and accessories needful for the photographic art' and provided instruction to beginners in photography. They boasted of being the proprietor of Lord Wemyss's famous cure for rheumatism – Rehtam – the greatest discovery of the age for all bodily pains. After graduating from Edinburgh University in 1832, Haddington's famous son, Samuel Smiles, dispensed drugs from this shop.

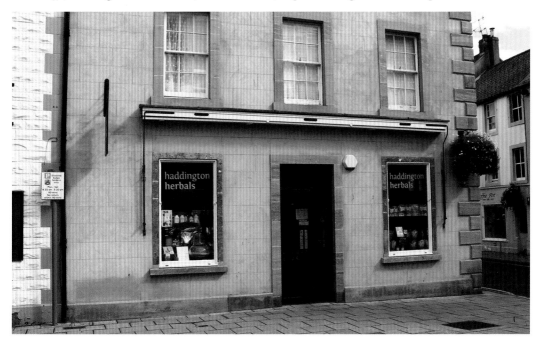

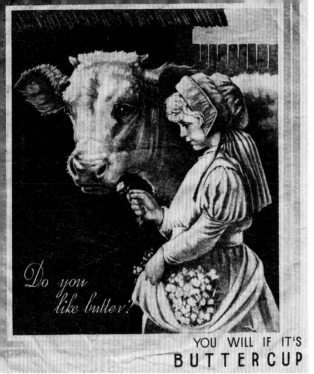

Do you like butter?

YOU WILL IF IT'S
BUTTERCUP

Buttercup Dairy, No. 6 Court Street
The shop at No. 6 Court Street was the location of Haddington's Buttercup Dairy. The tiled mural at the shop entrance shows a girl holding a buttercup under the chin of a large, sociable cow. The Buttercup Dairy Co. was founded by Andrew Ewing. Ewing opened a grocers in Dundee in 1894 and the first Buttercup Dairy opened in Kirkcaldy in 1904; within fifteen years it was one of the first chain stores, with 250 branches. The shops were known for their cleanliness and an all-female staff in crisp, white overalls. Ewing purchased Clermiston Mains, a large estate to the west of Edinburgh, and opened an enormous poultry farm that accommodated 200,000 hens. Ewing was a great philanthropist and gave all the eggs laid on a Sunday to local charities. As was his wish, he died close to being penniless in 1956, having spent a great part of his life supporting good causes.

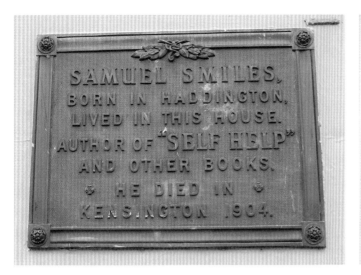

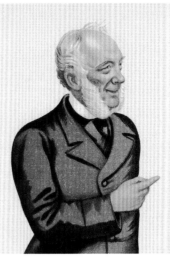

Samuel Smiles

The decorative plaque on the building at No. 64 High Street commemorates the birthplace and early home of Samuel Smiles (1812–1904), a surgeon, journalist, writer, social reformer and Victorian celebrity. Smiles trained in medicine at Edinburgh University and practised as a doctor and pharmacist in Haddington. He later moved to Leeds and abandoned medicine to become editor of the *Leeds Times*, where he championed women's suffrage. He published biographies of many eminent Victorians, including George Stephenson and Josiah Wedgwood. In 1859, he published *Self-Help with Illustrations of Character and Conduct*, which was to become a Victorian bestseller. The book encouraged people to prosper by self-improvement, hard work, education and thrift. It was followed by a number of other similar books: *Character* (1871), *Thrift* (1875) and *Duty* (1880). His books influenced a generation of Victorians. Haddington had a major influence on Smiles' concept of self-help. He was from a family of eleven and his early schooling stopped when he was fourteen. His widowed mother supported him and the rest of the family by running a shop in Haddington, and her example was a model of the benefits that hard work could bring.

Drink of the pure crystals
And not only be ye succoured
But also refreshed in the mind.
To the mortal and immortal memory
And in noble tribute to her
Who not only gave a son to Scotland
But to the whole world
And whose own doctrines
He preached to humanity
That we might learn.

Haddington's Connection to Robert Burns

Just outside of Haddington are two sites closely associated with the family of the national bard, Robert Burns. In 1800, after the death of Robert Burns in 1796, his mother, brother and sister moved to the area. Robert's brother, Gilbert, came to manage the farm at Morham West Mains and in 1804 was appointed the factor at Lennoxlove. He was an elder of Bolton kirk and supervised the building of the new church. Jane Welsh was particularly friendly with Gilbert's daughters and was a frequent visitor to their house. Gilbert's children attended the burgh school in Haddington and the family would have known the town well. The two sites are the location of the family home and the well at which Burns' mother drew water for the family.

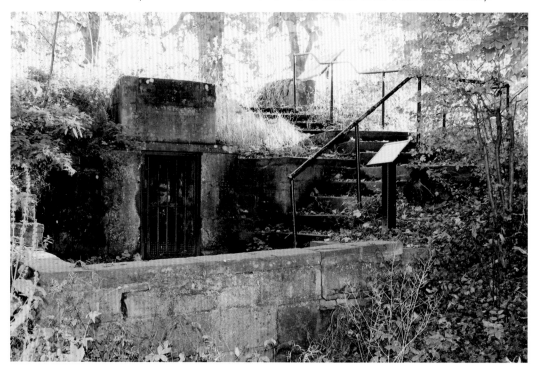

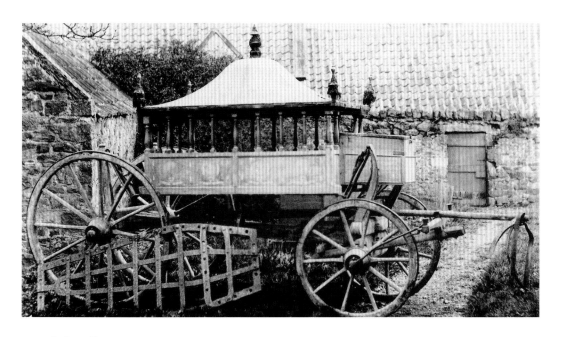

Bolton Hearse

Bolton is a picturesque little village 3 miles south of Haddington. The most noteworthy buildings are the parish church dating from 1809 and the eighteenth-century circular dovecote. In 1783, the Bolton kirk session purchased a horse-drawn hearse that survives to this day and is believed to be the oldest vehicle in Scotland. It was in use in Bolton until 1844, after which it was stored in a building in the kirkyard until it was donated to the Royal Scottish Museum in 1932. Burns' mother and his brother Gilbert, who was an elder of the kirk, and numerous other members of the family would have been conveyed in the Bolton hearse to their last resting place in the family plot at the Bolton kirkyard.

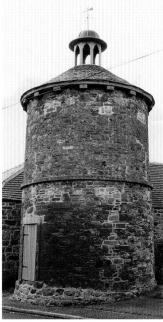
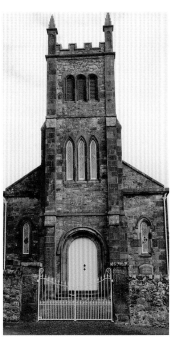

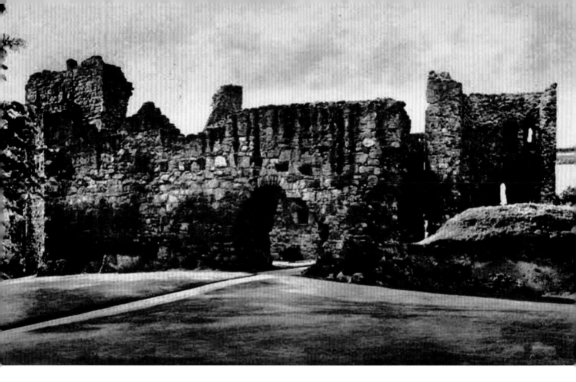

Hailes Castle

The substantial ruins of Hailes Castle are located around 4 miles east of Haddington along a single track road and hidden away in a peaceful riverside setting on a bend of the River Tyne. The castle originates from the early thirteenth century when it was a fortified tower house for the Earls of Dunbar and is one of Scotland's oldest castles. It was later held by the Hepburn family and Mary, Queen of Scots was entertained by her third husband James Hepburn, 4th Earl of Bothwell, at Hailes. There are two vaulted pit prisons and a dovecote in the original tower. It has been in the care of the state since 1926.

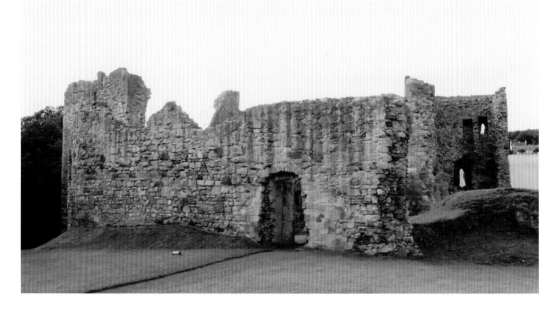

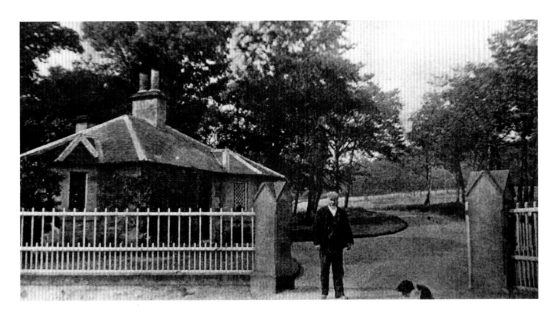

Kilduff Lodge

A man, presumably the lodge keeper, and his dog stand at the entrance to Kilduff House. The lodge is on the B1343 road, 1 mile west of Athelstaneford. Kilduff House is a small mid-eighteenth-century mansion which was built by John Home (1722–1808). Home had a remarkable life. He studied divinity at Edinburgh University, was taken prisoner by Bonnie Prince Charlie's forces in 1745, became minister at Athelstaneford in 1746, was a friend of David Hume and tutored the Prince of Wales. He is most famously known as author of the immensely successful tragedy *Douglas*, which was first performed in Edinburgh in 1756. It was met with such intense fervour that a member of the audience is reputed to have called out 'Whaur's yer Wullie Shakespeare noo?' Home had Kilduff House built in 1767 close to his old parish.

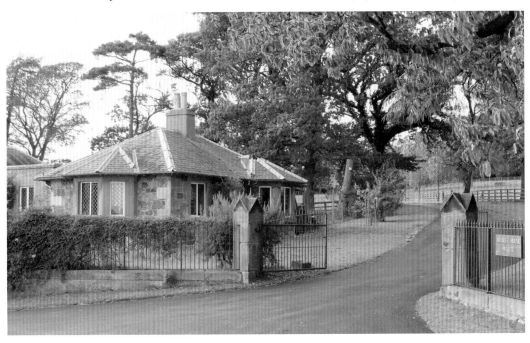

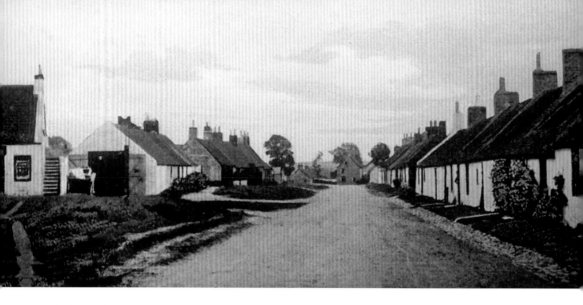

Athelstaneford

Athelstaneford, pronounced locally as 'Elshinthurd', lies 3 miles north-east of Haddington. It was established by a local landowner as a planned village in the mid-eighteenth century. Low whitewashed and pantiled single-storey cottages stretch along both sides of the wide road. The village is the legendary home of the Scottish Saltire. The well-known story has it that in AD 832, a Pictish army was mustered in the area for a battle with the invading Angles. Before the battle, St Andrew appeared in a vision to Óengus II, the leader of the Picts, and predicted their victory. The following day, clouds formed a white cross in a blue sky and the Picts went on to win the battle. The village is also said to take its name from Athelstane, the leader of the Angles, who was killed at a local river crossing by Angus McFergus the Pict. The legend has made Athelstaneford an important site on the Saltire Trail with the National Flag Heritage Centre based in an old doocot in the village.

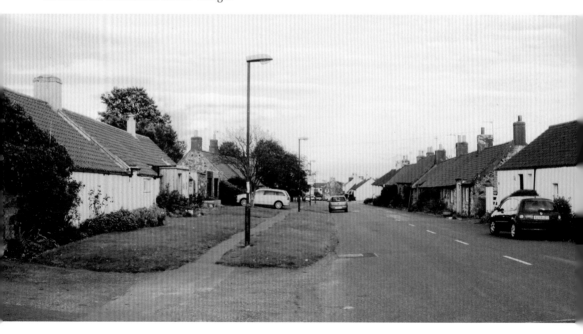

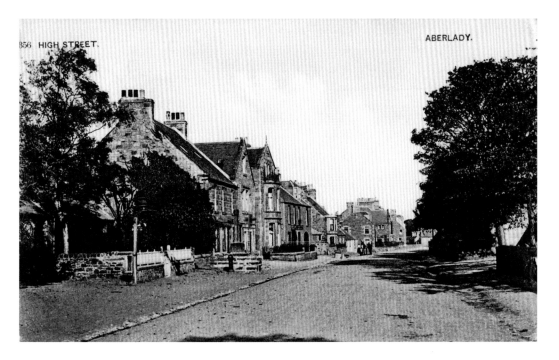

Aberlady

Aberlady was Haddington's port from the fourteenth century onwards and the town's link to trading partners on the continent. Aberlady Bay was previously much deeper than its present level and ships were able to anchor close to the village. Haddington even maintained a property at Aberlady, known as Haddington House, to administer their shipping interests. The advent of the railways made the harbour redundant in the mid-nineteenth century.

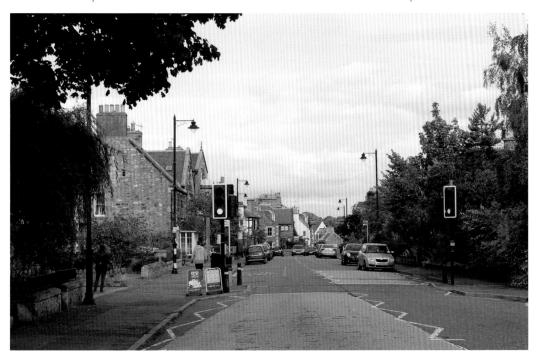

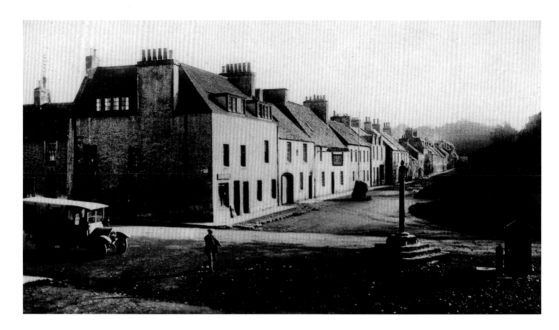

Gifford

The pretty little village of Gifford lies approximately 3 miles south of Haddington. Gifford has always been closely associated with the Yester Estate. The village of Bothans (bothies or workers' cottages) in the parish of Yester, was named after Saint Bothan (the patron saint of ignorance or illiteracy). The village had developed close to Yester Castle and, in the seventeenth century, the villagers were moved to a new planned town in its present location on the opposite side of the Gifford Water to improve the privacy of Yester House.

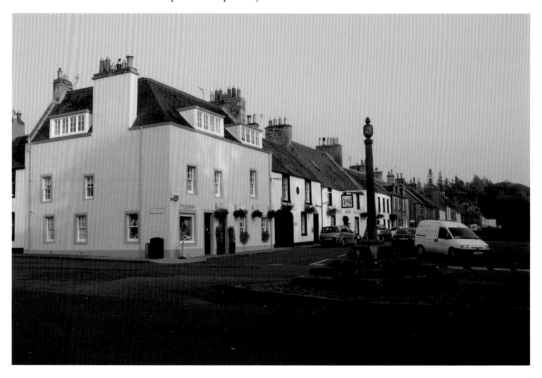

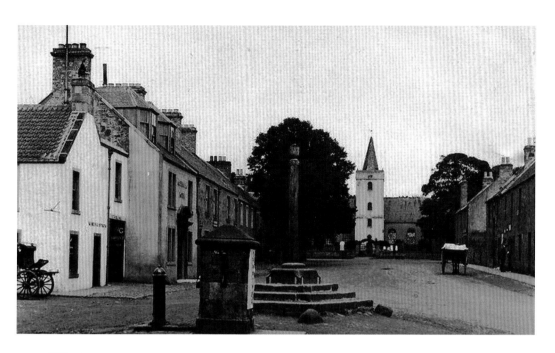

Gifford

The images show the Gifford town well and market cross in the foreground. Gifford's most eminent son is John Knox Witherspoon (1723–94), who was a signatory to the American Declaration of Independence and the President of Princeton University.

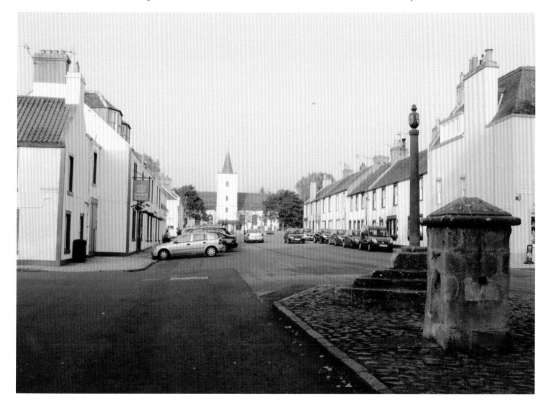

Traprain Law

The prominent elevated oval-shaped ridge of Traprain Law is a natural landmark 4 miles east of Haddington. It was historically known as Dunpendyrlaw and the name Traprain dates from the eighteenth century. It was a prehistoric fortress and a major stronghold of the Votadini tribe in the first century AD. The Votadini were later established at Din Eidyn – the castle rock of Edinburgh. A large treasure trove of Roman silver was found on the hill in 1919. Legend has it that the 8-foot-high standing stone, known as the Loth Stone, close to Traprain Law, marked the grave of the Pictish King Loth, from whom Lothian takes its name. The stone has been moved slightly from its original position to allow easier ploughing.